DRAW 62 MAGICAL CREATURES

AND MAKE THEM CUTE

STEP-BY-STEP DRAWING FOR CHARACTERS AND PERSONALITY

For Artists, Cartoonists, and Doodlers

HEEGYUM KIM

QUARRY

CONTENTS

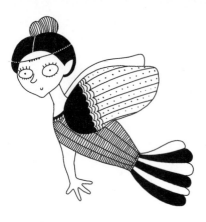

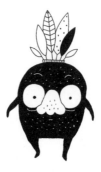
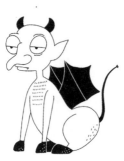
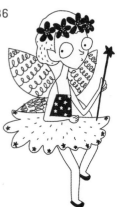

INTRODUCTION

Learning to draw characters is an exciting and fun way to build your illustration skills, and when the creatures are magical, you can develop your imagination as well. One way to approach a drawing is to do some research. You may find inspiration for your creatures in children's books, mythology, or in cartoons and movies.

Researching these characters was challenging—some have little information and scant visual reference. Many of the creatures are animal hybrids, such as an eagle and a horse, a goat and a tiger, or a human and an animal. For these, I referenced each part separately. I looked up medieval fashions to inspire the fairy and to add details to other gothic characters. Try to get into the mood of the creature while you are drawing. When I was drawing the mummy, I played *The Mummy* and ended up watching all of the series. And when I was drawing the Boogey Man, scary images from horror movies were covering my screen!

Drawing is a wonderful activity, whether you do it for fun or as a job. And it's good for you. Studies have shown that drawing improves creativity, memory, communication skills, and problem-solving skills. In addition to improving physical dexterity and brain/body coordination, drawing also provides stress relief, an outlet for emotions, and increases your emotional intelligence. I work as a graphic designer at my daytime job, but I look forward to my evenings and weekends when I spend much of the time drawing.

How to Use this Book

Use this book as a guide and reference to develop your own magical creatures. On the left-hand page of each creature spread, follow along with the step-by-step guide to draw the basic form. Concentrate on main geometric shapes that combine to make the figure. Then, add identifying features such as eyes, wings, or feet. Lastly, fill in the facial attributes that bring the character to life. After you master the basic drawing of the creature, then use the right-hand page to inspire further drawings of this character in various poses, with different expressions, or engaging in interesting activities. There are spaces throughout the book for you to draw, or feel free to use your favorite paper, drawing pad, or sketchbook. Tips are sprinkled throughout to give you creative ideas and technique suggestions.

Experiment with a variety of drawing tools to get familiar with how they feel and the kind of marks they make. Most of the drawings here begin with pen or pencil lines and sometimes feature colored pencil for variety.

Remember, the best way to get better at drawing is to draw! Set up a regular practice time or find time where you can. I hope this book provides you with loads of fun ways to expand your drawing skills and your imagination.

DRAW A DRAGON

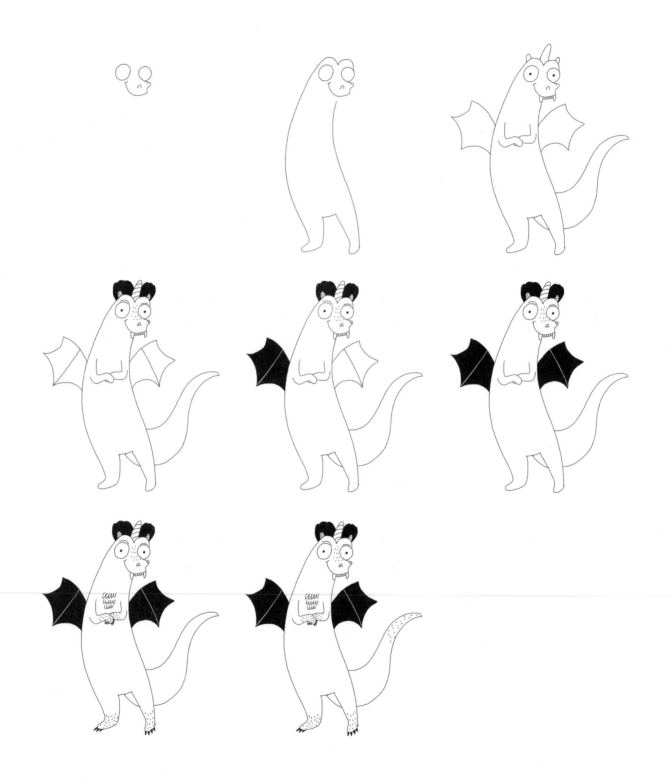

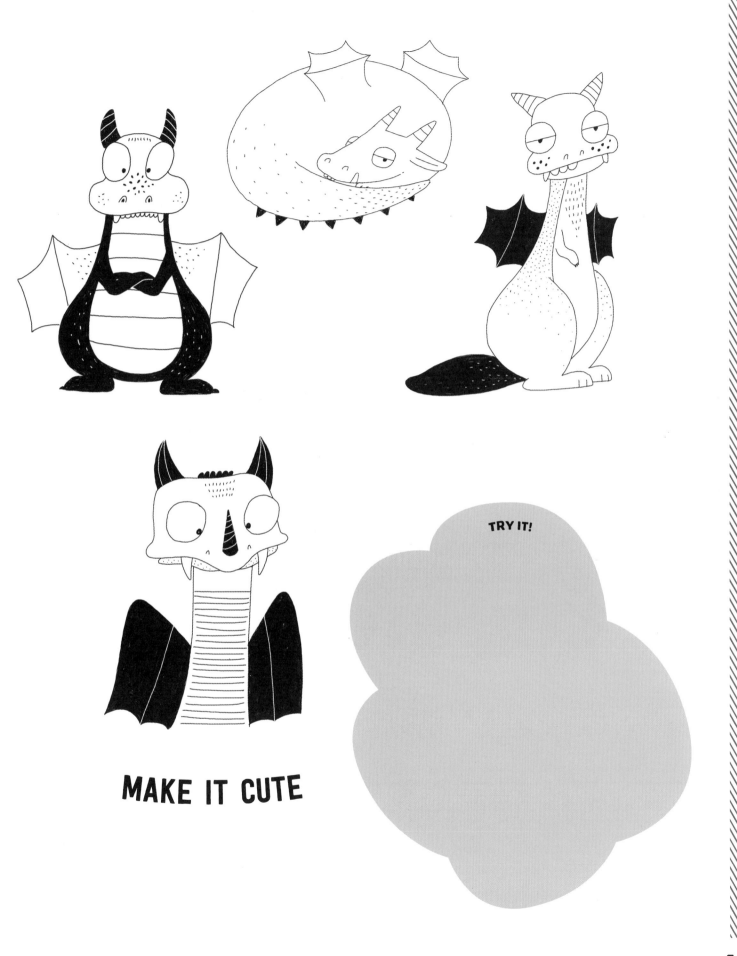

MAKE IT CUTE

TRY IT!

DRAW A UNICORN

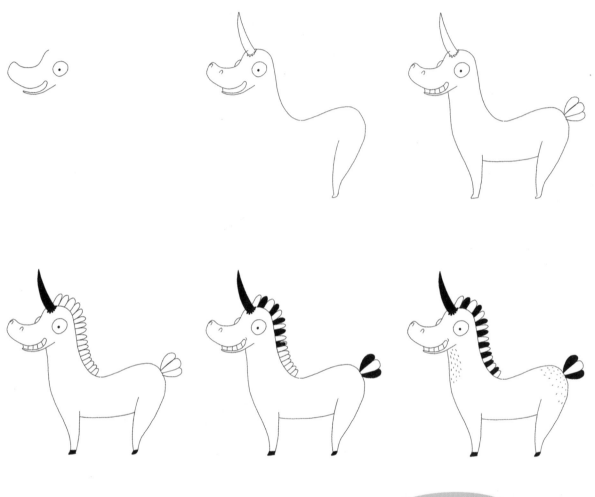

TRY IT!

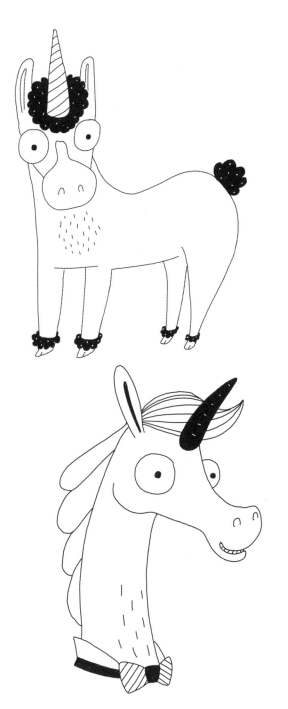

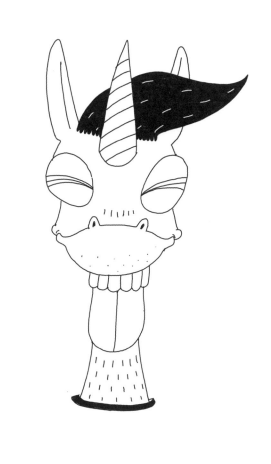

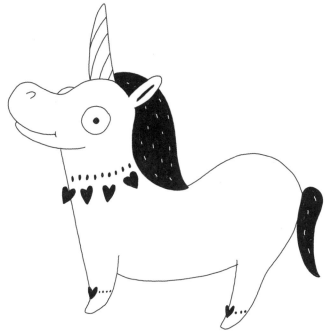

> **TIP** ← Sometimes, starting with the face will help guide the direction of your drawing. Since this unicorn was wide-eyed and smiling, I tried to enforce this happy persona by using a playful scallop design for its mane and perky tail. Think about how the facial expression can be reinforced with other elements of your drawing.

MAKE IT CUTE

DRAW A DODO

TRY IT!

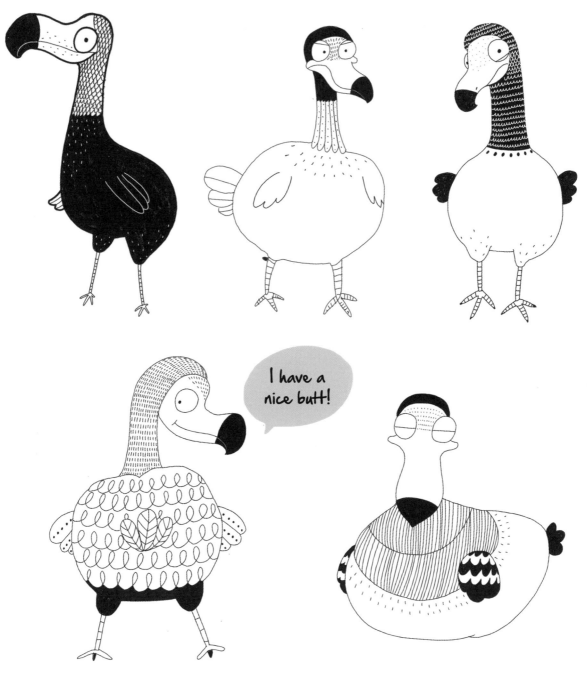

MAKE IT CUTE

DRAW A MERMAID

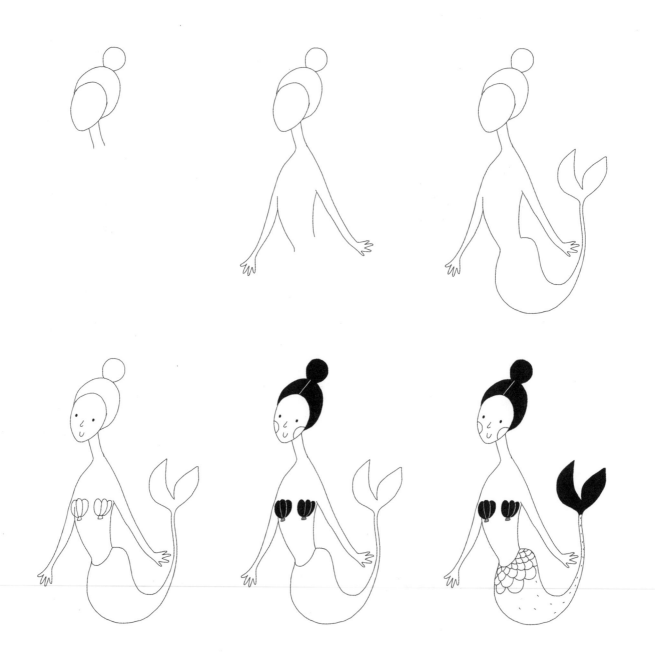

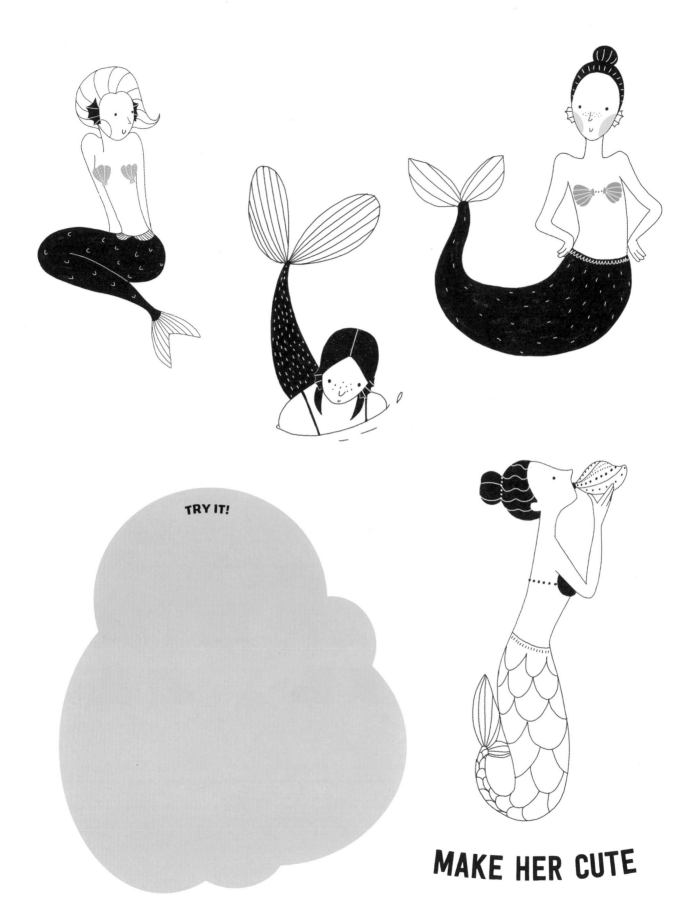

TRY IT!

MAKE HER CUTE

DRAW A GNOME

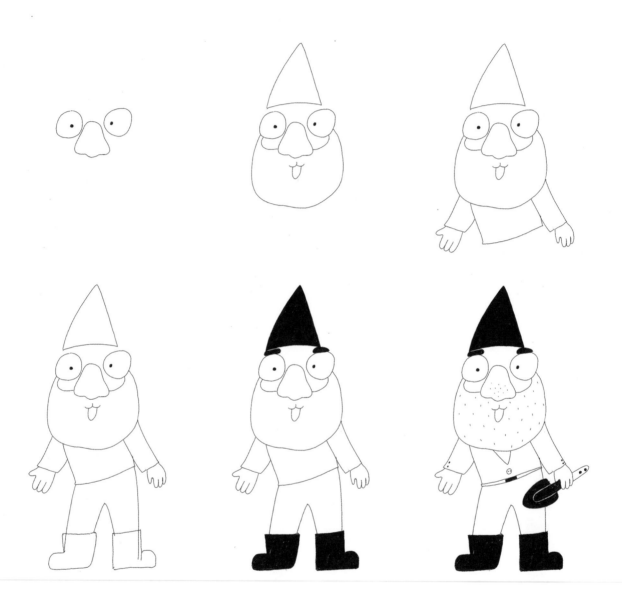

→**TIP**← After you complete a simple line drawing, fill in select areas with solid black to create depth. The black hat, brows, and boots helped to initially frame the figure, and adding a small black buckle and trowel provided balance in the final version.

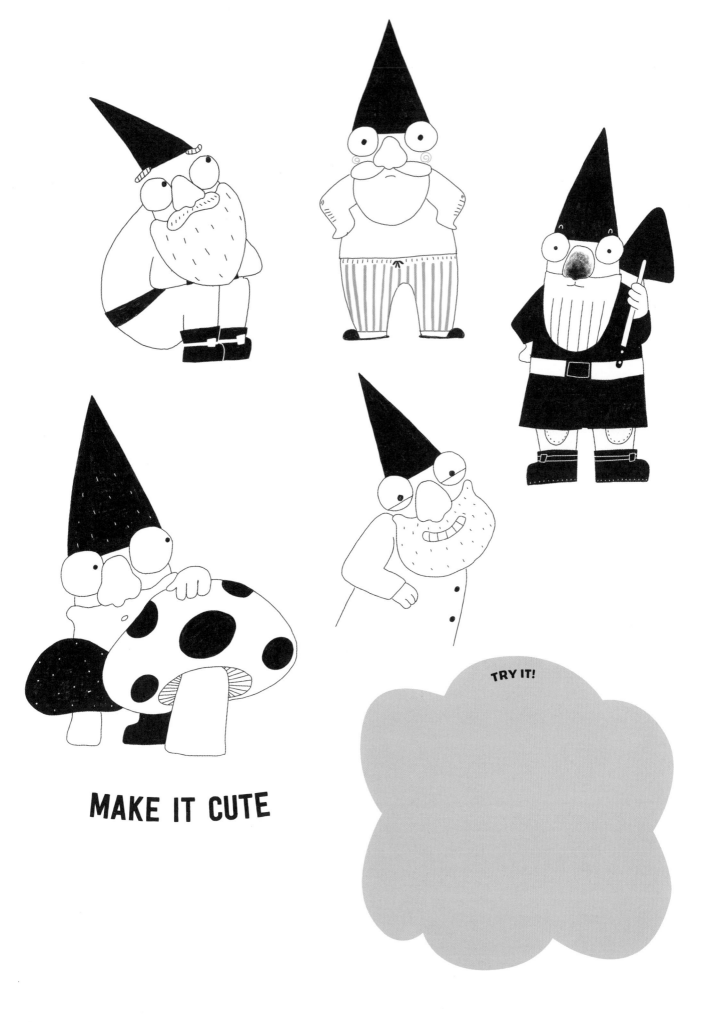

MAKE IT CUTE

TRY IT!

DRAW A MANDRAKE

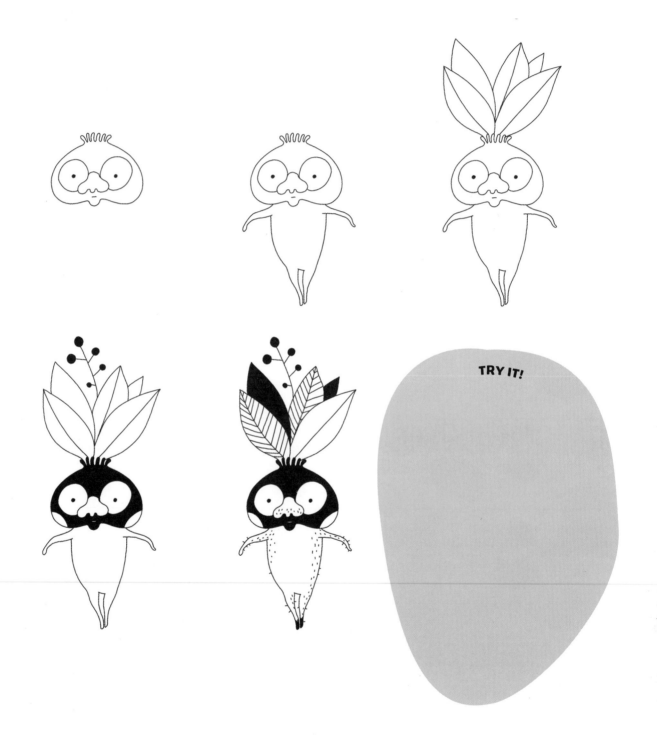

TRY IT!

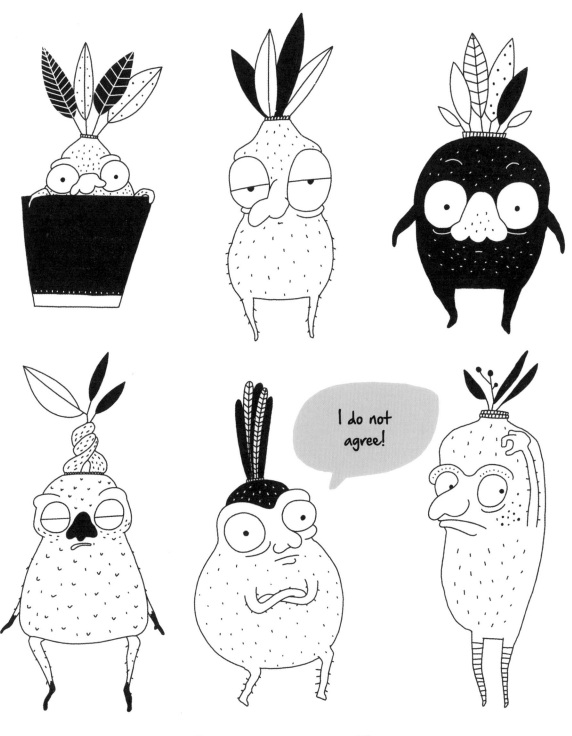

MAKE IT CUTE

DRAW AN ANGEL

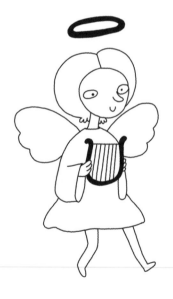 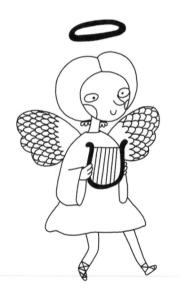 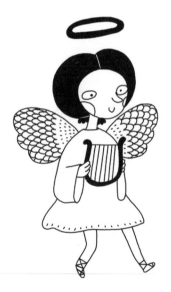

→**TIP**← Pay attention to small details as you finish **your sketch.** The feather pattern in the wings adds nice texture to this drawing. The repetitive lines in the harp mimic the density of the feathers. The dots on the wing interior are echoed along the edge of the skirt, creating a nice harmony.

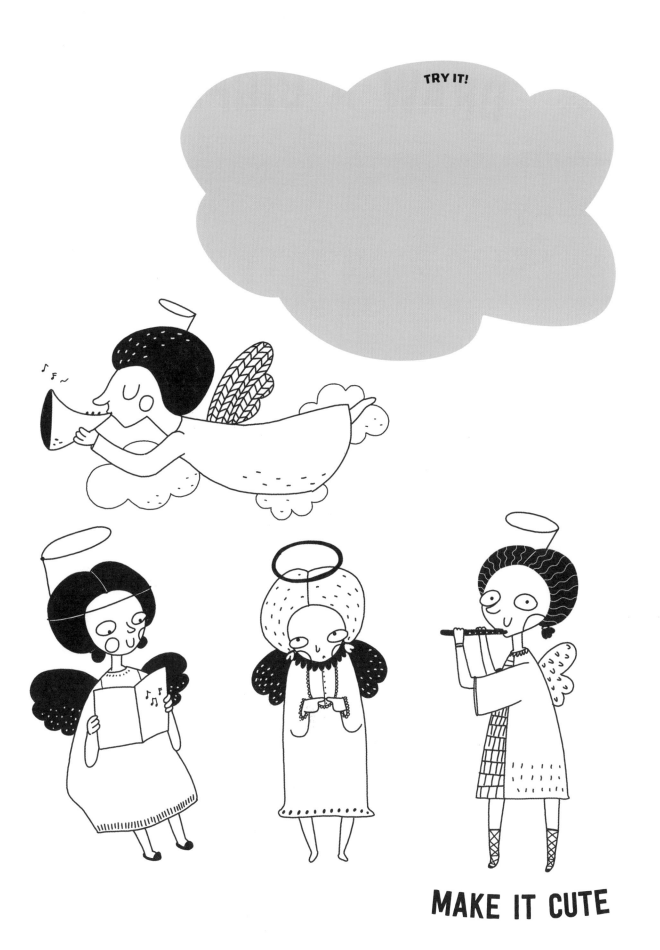

MAKE IT CUTE

DRAW A BIGFOOT

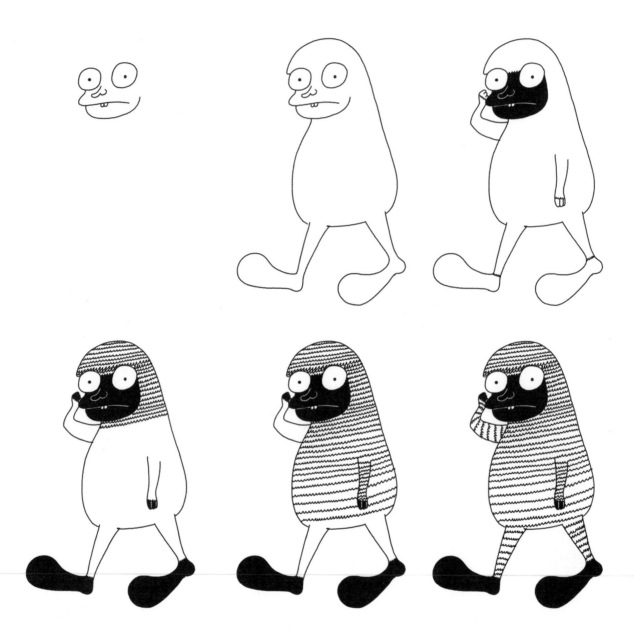

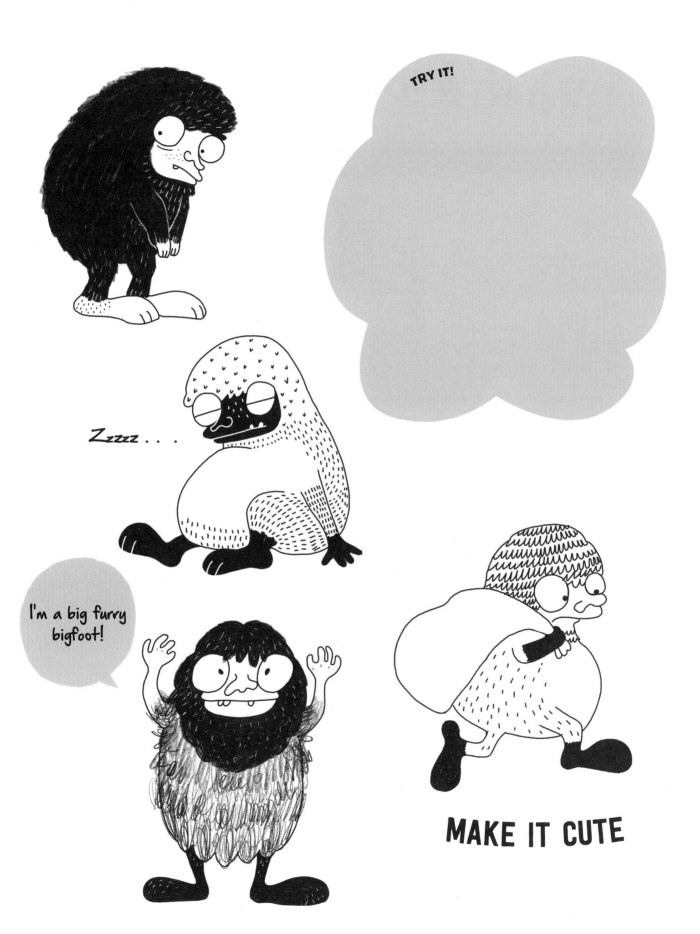

TRY IT!

Zzzz . . .

I'm a big furry bigfoot!

MAKE IT CUTE

19

DRAW A BOOGEY MAN

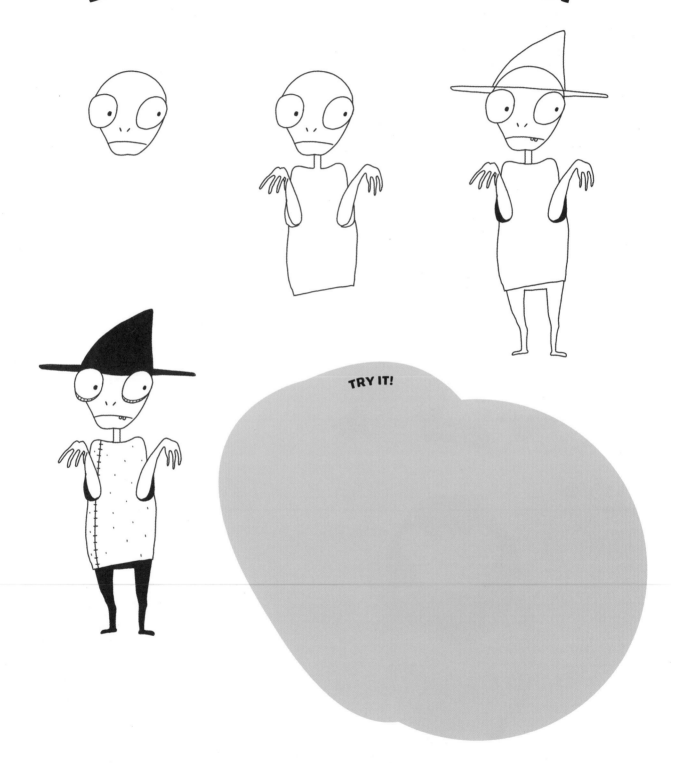

TRY IT!

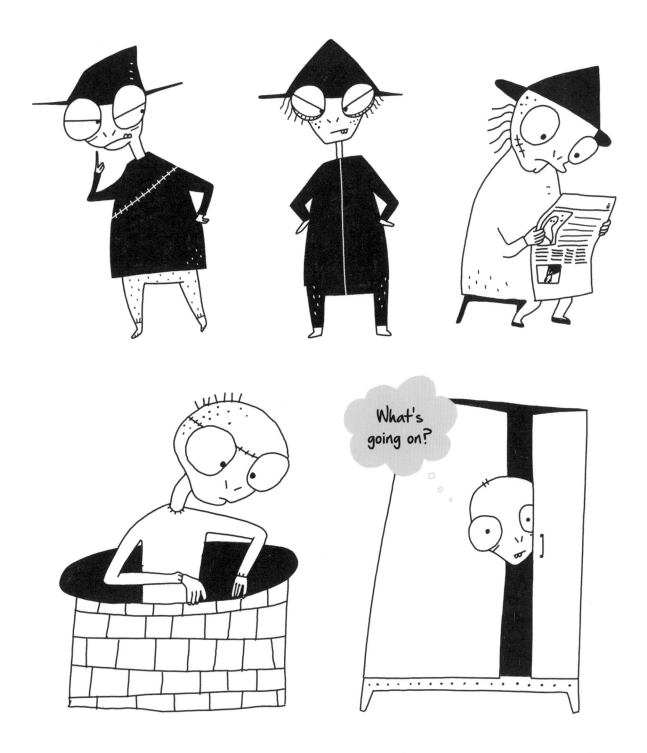

MAKE HIM CUTE

DRAW A BROWNIE

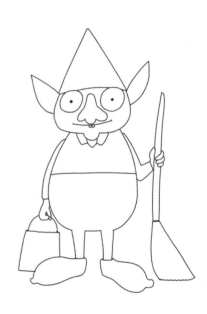

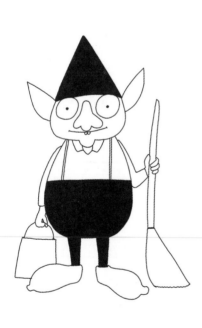
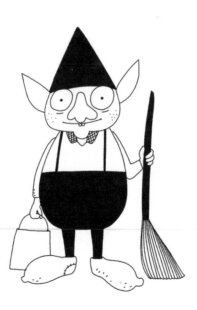
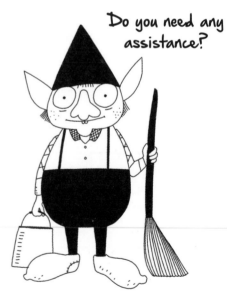

Do you need any assistance?

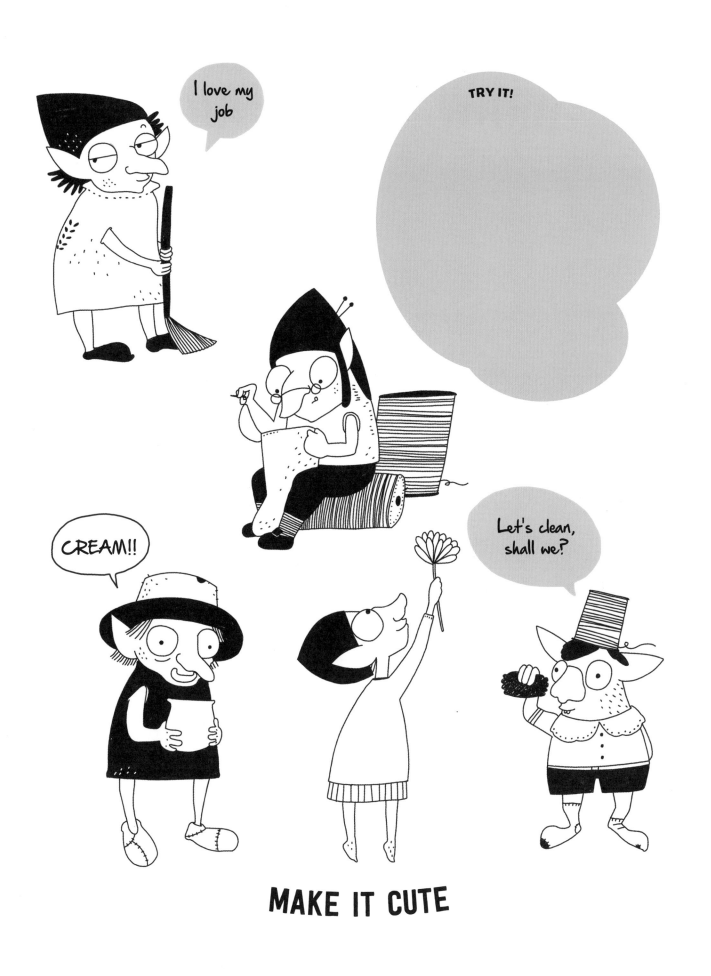

MAKE IT CUTE

DRAW A CENTAUR

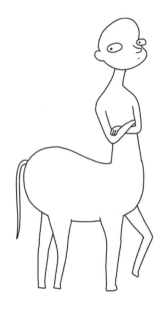

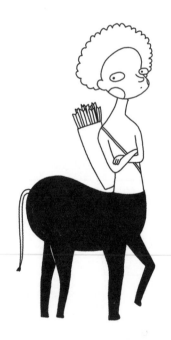

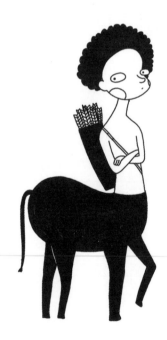

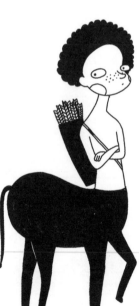

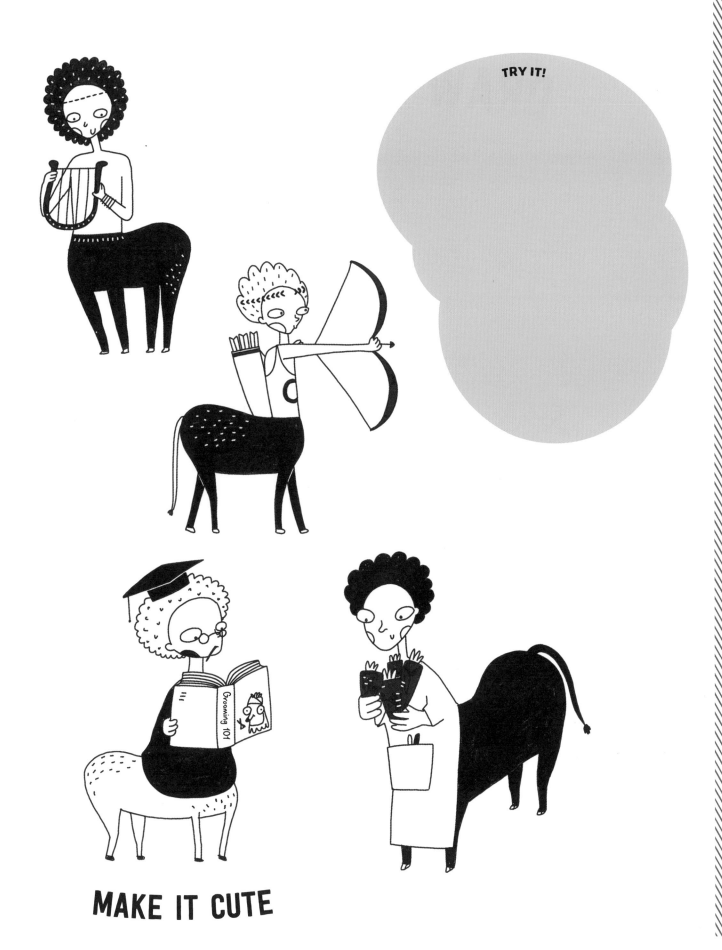

MAKE IT CUTE

25

DRAW A CHIMERA

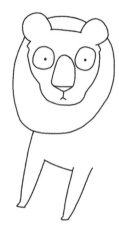

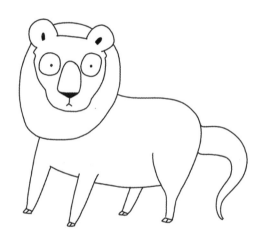

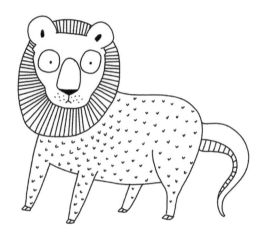

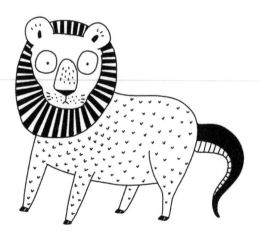

→**TIP**← In Greek mythology, a Chimera is a hybrid monster with a lion's head, a goat's body, and a serpent's tail. How many ways can you re-imagine this creature by blending characteristics of three different animals?

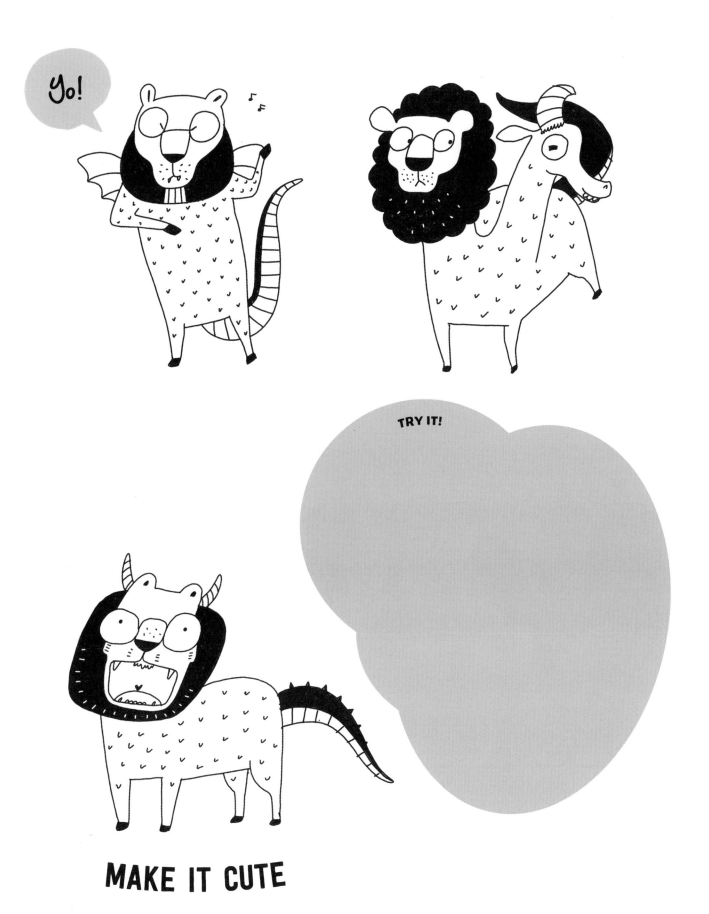

MAKE IT CUTE

DRAW A CYCLOPS

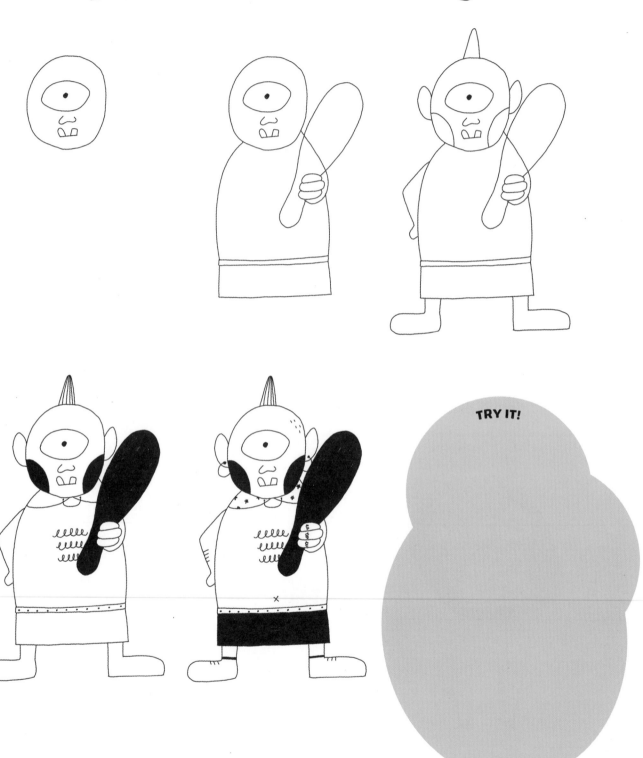

TRY IT!

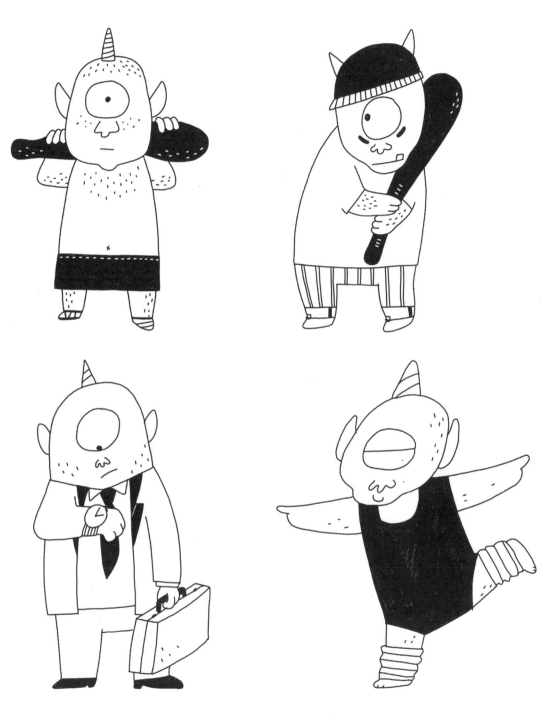

MAKE IT CUTE

DRAW A DEMON

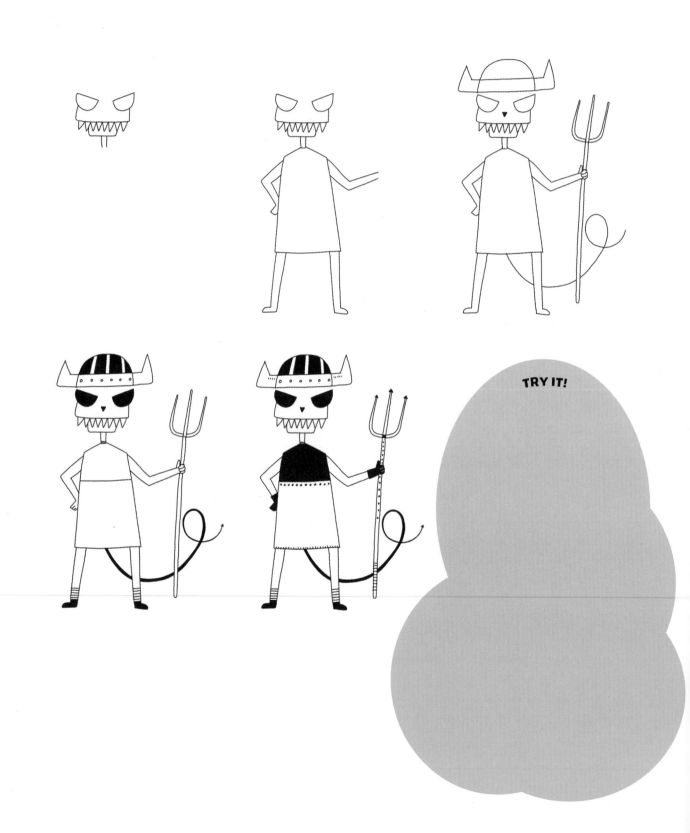

TRY IT!

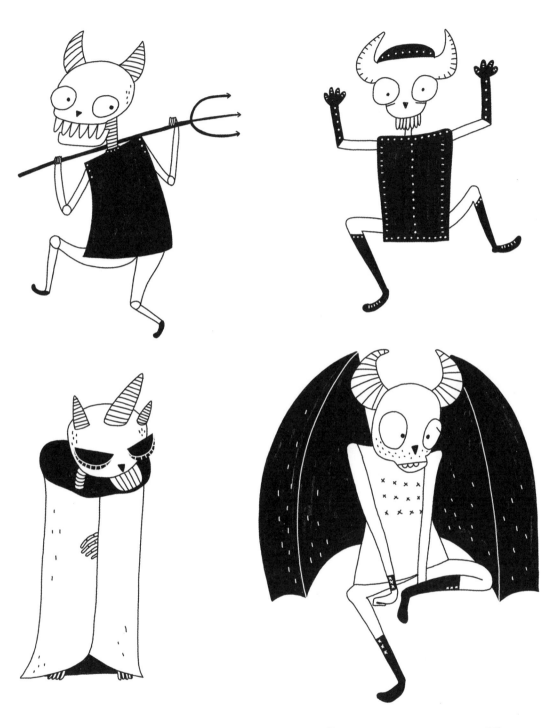

MAKE IT CUTE

DRAW A DWARF

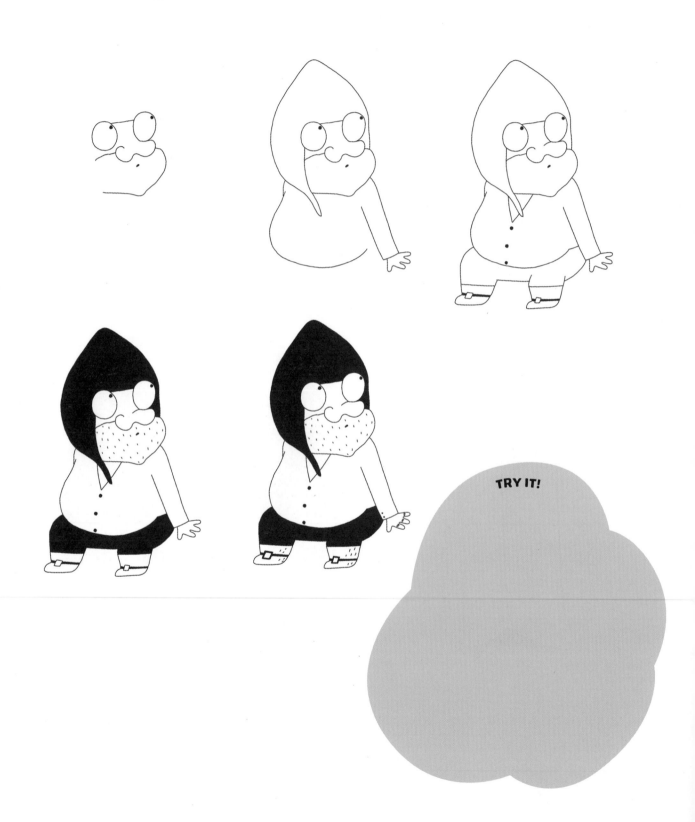

TRY IT!

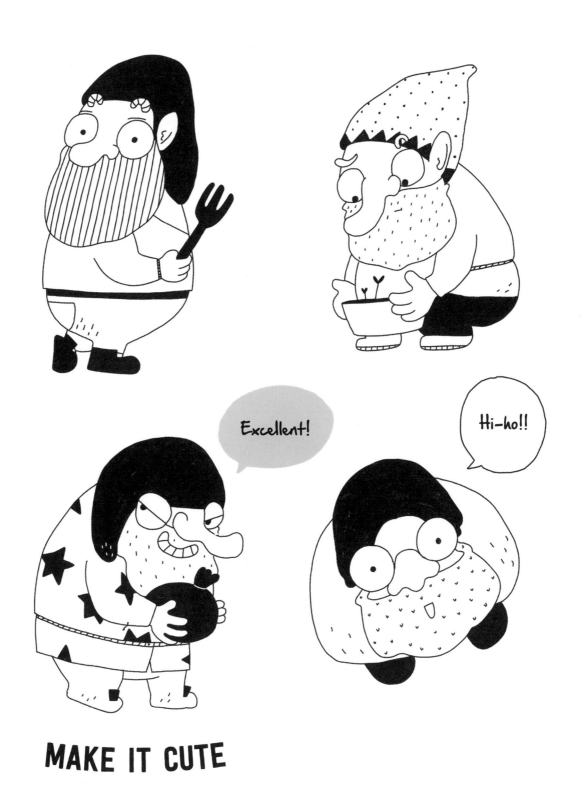

MAKE IT CUTE

DRAW AN ELF

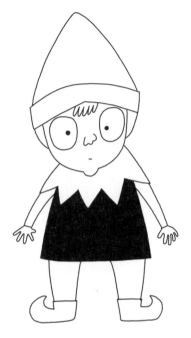

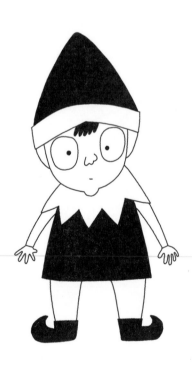
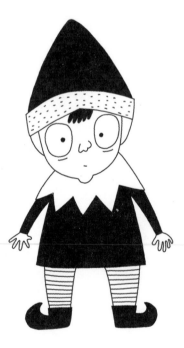

TRY IT!

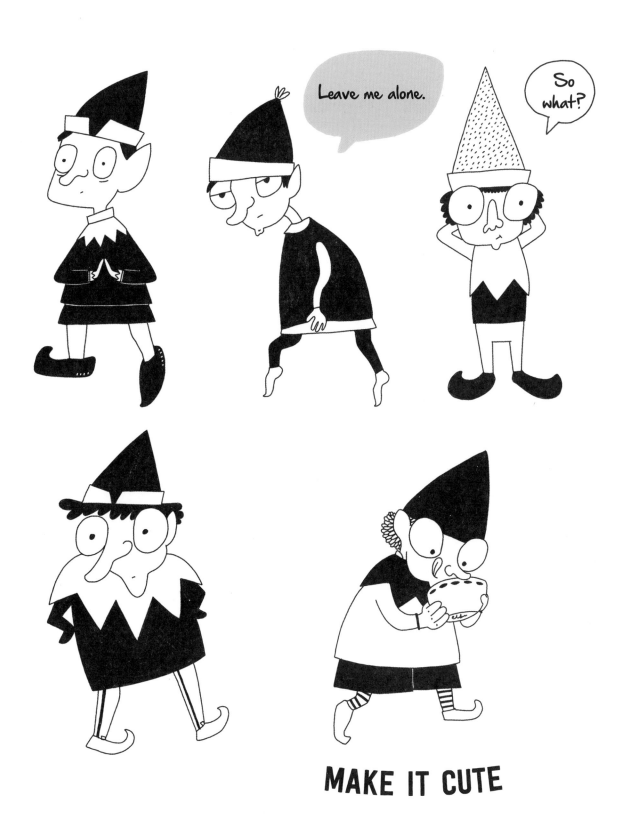

MAKE IT CUTE

DRAW A FAIRY

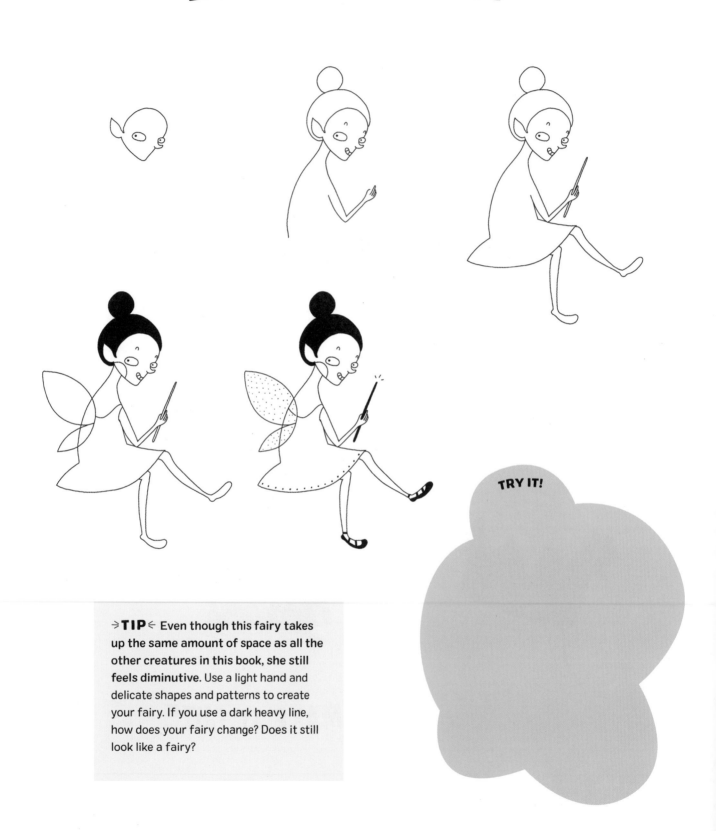

TRY IT!

→ **TIP** ← Even though this fairy takes up the same amount of space as all the other creatures in this book, she still feels **diminutive.** Use a light hand and delicate shapes and patterns to create your fairy. If you use a dark heavy line, how does your fairy change? Does it still look like a fairy?

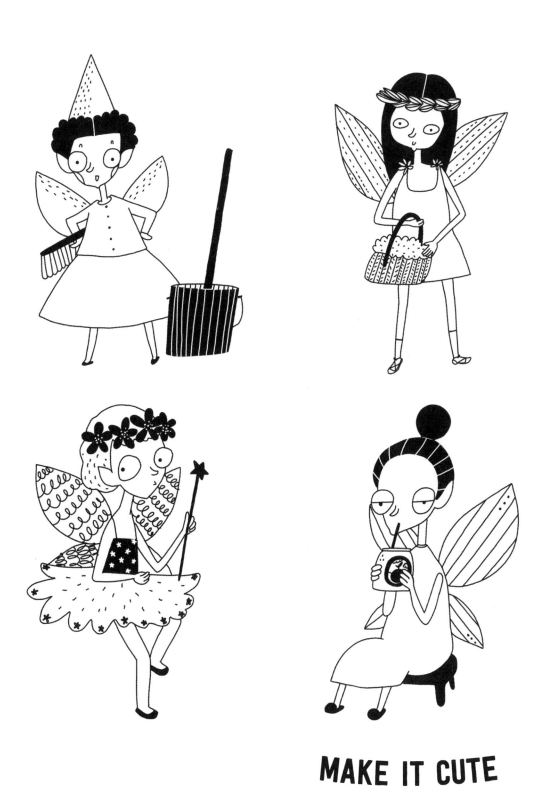

MAKE IT CUTE

DRAW A FAUN

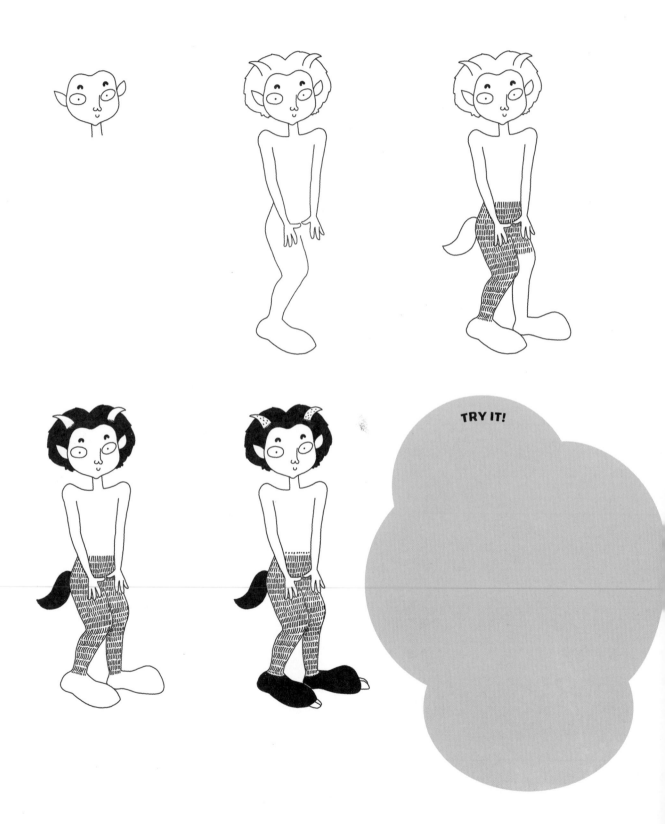

TRY IT!

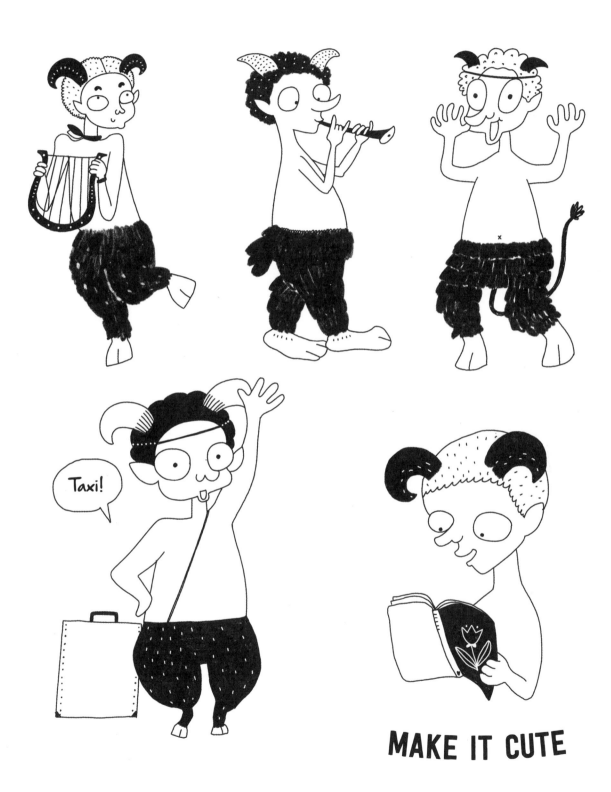

MAKE IT CUTE

DRAW FRANKENSTEIN

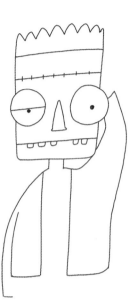
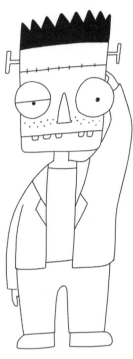
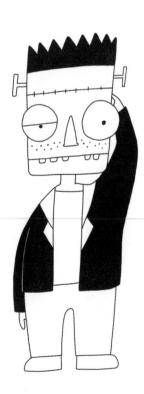
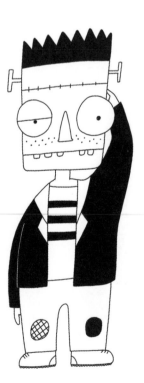
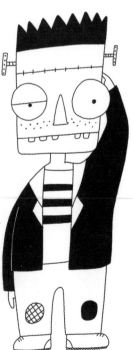

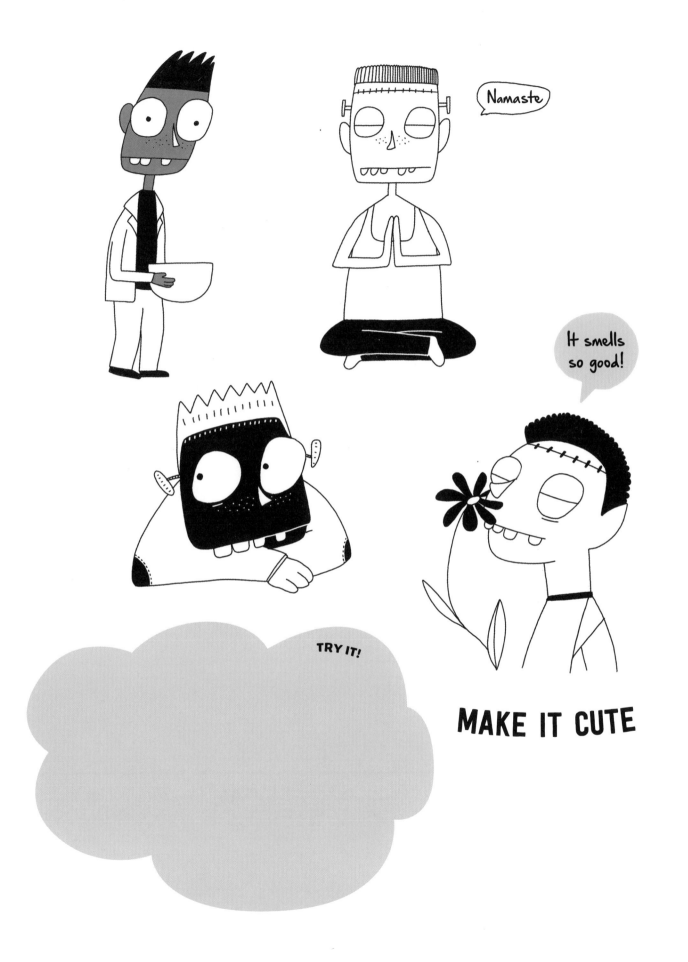

Namaste

It smells
so good!

TRY IT!

MAKE IT CUTE

DRAW A GARGOYLE

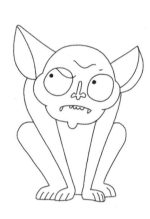

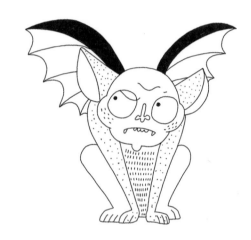

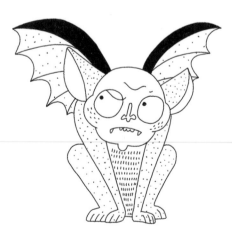

TRY IT!

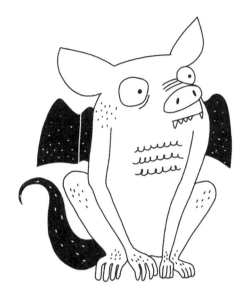

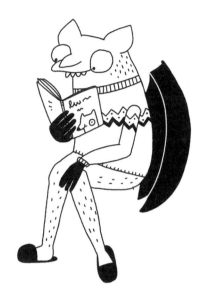

Daydreaming

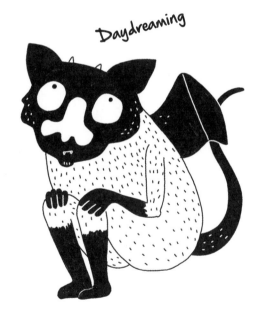

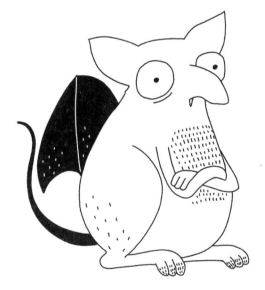

MAKE IT CUTE

DRAW A GHOST

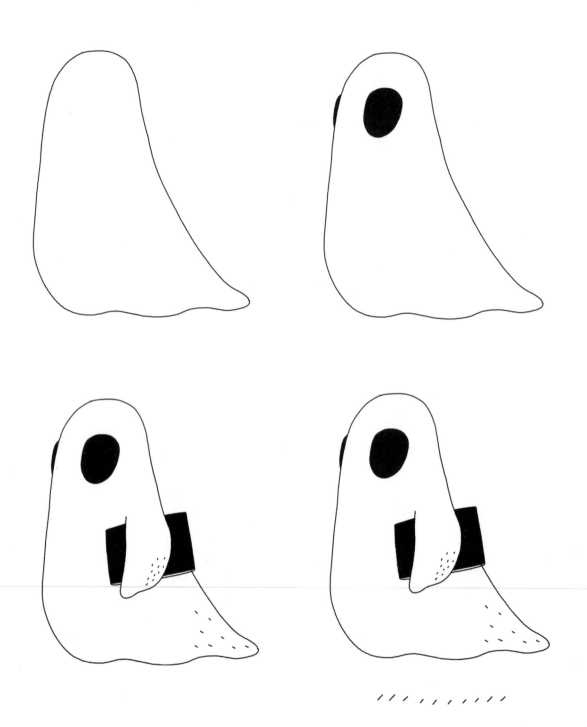

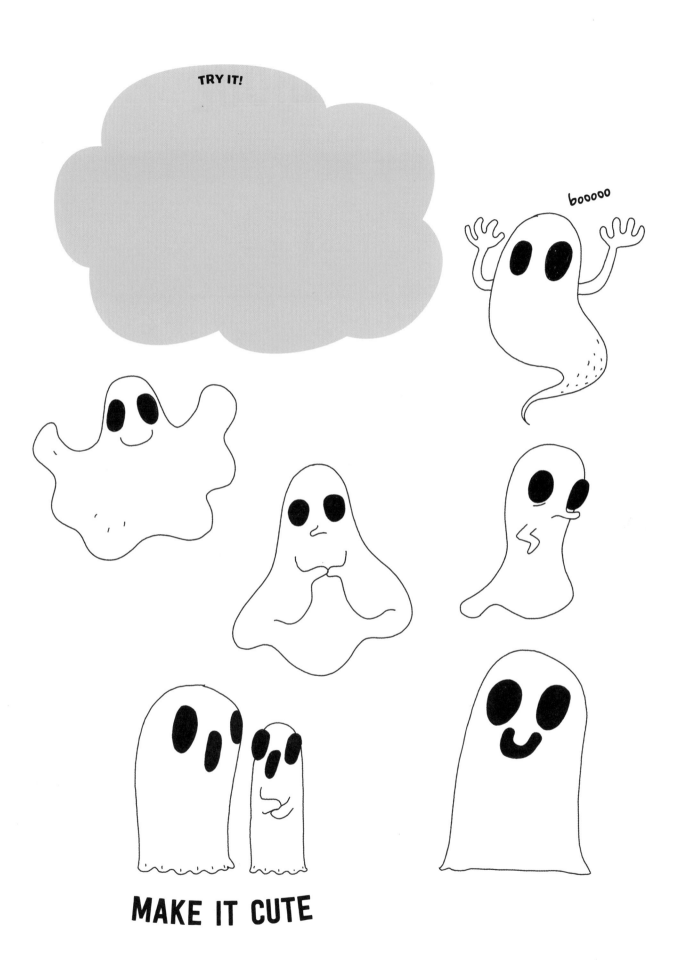

TRY IT!

booooo

MAKE IT CUTE

DRAW A GHOUL

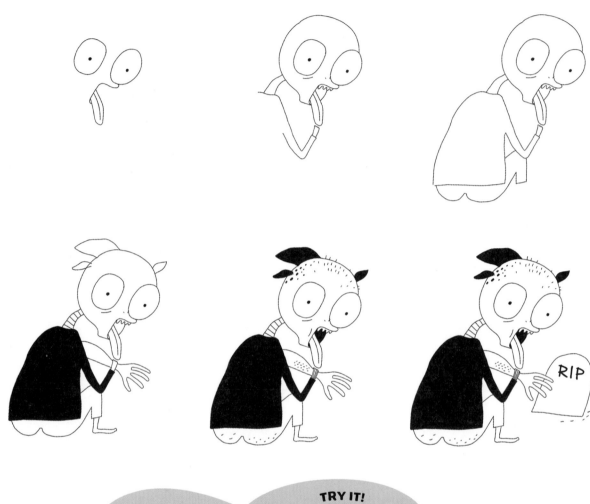

TRY IT!

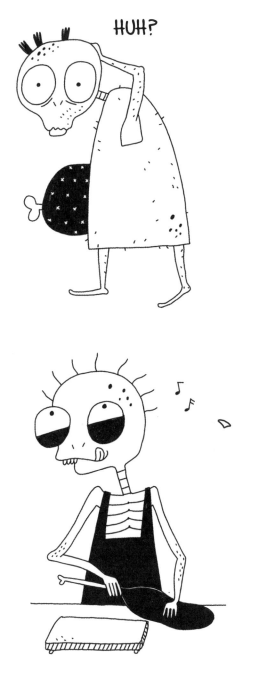

HUH?

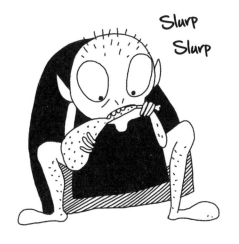

Slurp
Slurp

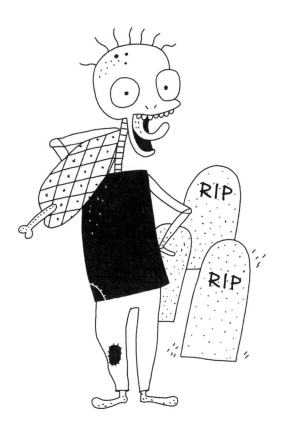

RIP

RIP

MAKE IT CUTE

DRAW A GOBLIN

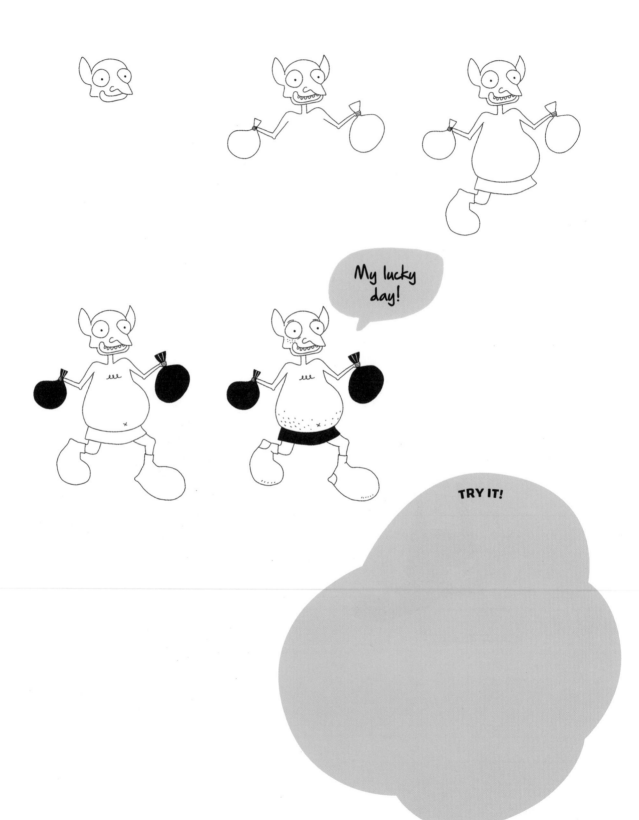

My lucky day!

TRY IT!

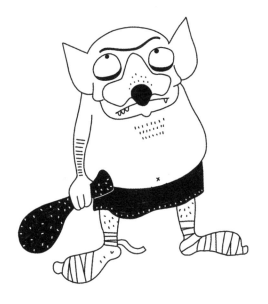

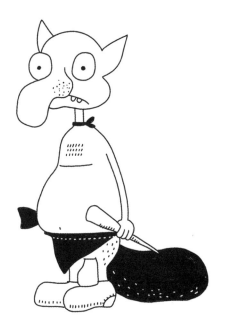

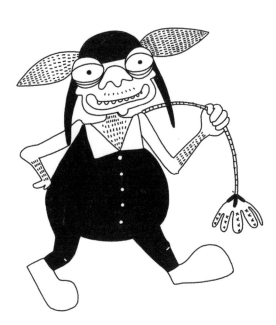

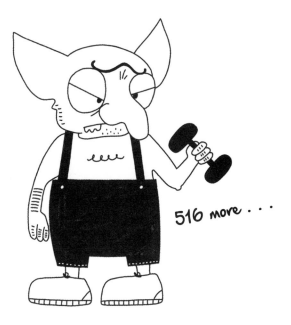

516 more . . .

MAKE IT CUTE

⇗**TIP**⇐ In folklore, goblins are small, grotesque, malicious, and greedy. What mischief is your goblin getting into? Use your imagination to animate your goblin by showing him in the act: Exactly what act is up to you!

DRAW A GRIFFIN

 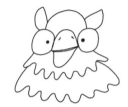

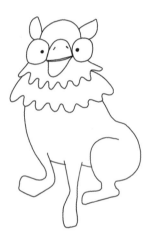 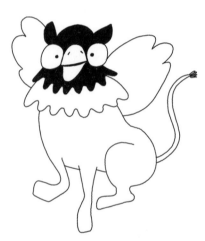

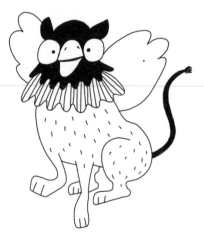 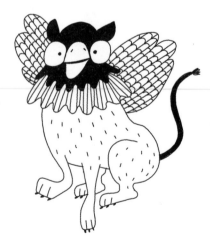

TRY IT!

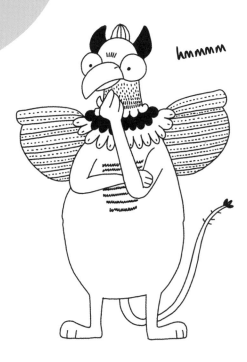

hmmmm

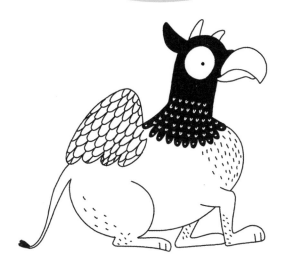

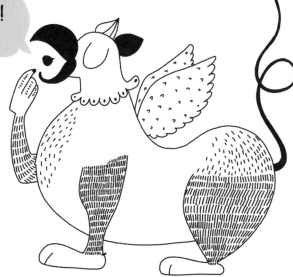

Yum!

MAKE IT CUTE

DRAW A HIPPOGRIFF

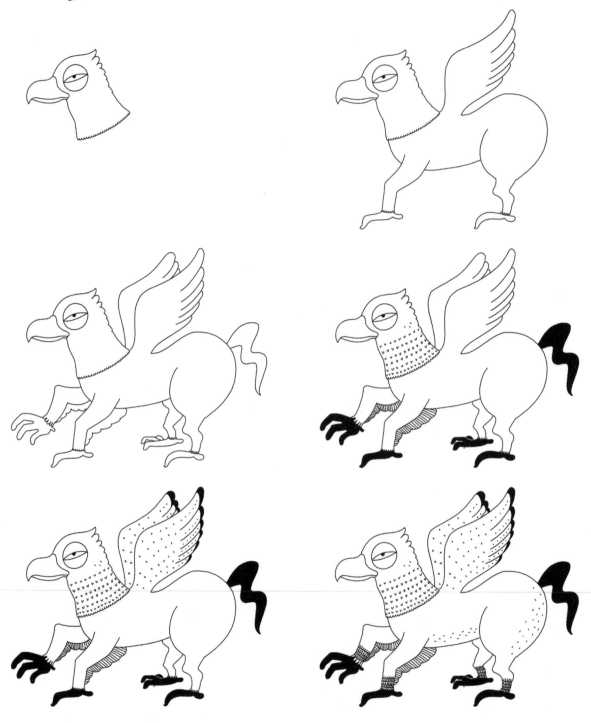

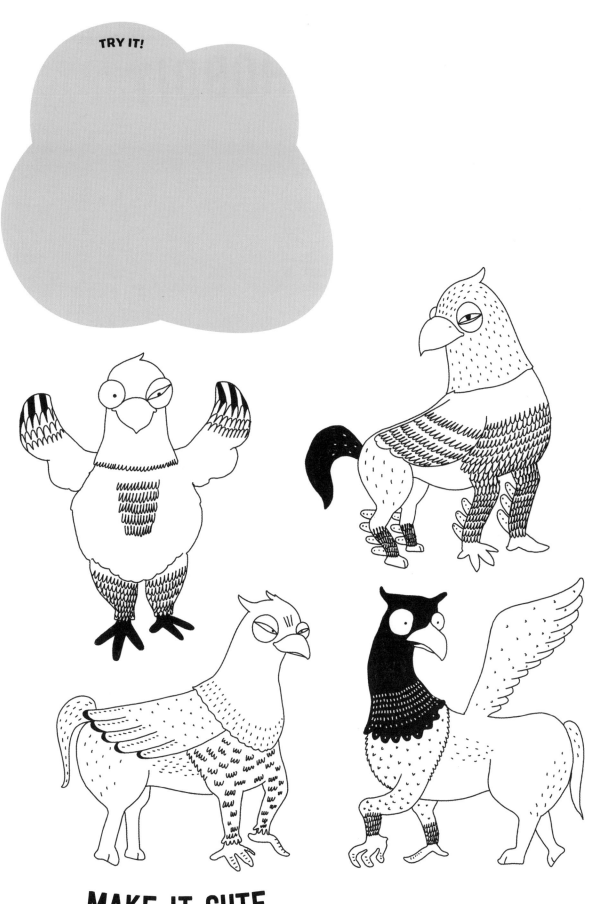

TRY IT!

MAKE IT CUTE

DRAW A HOBBIT

TRY IT!

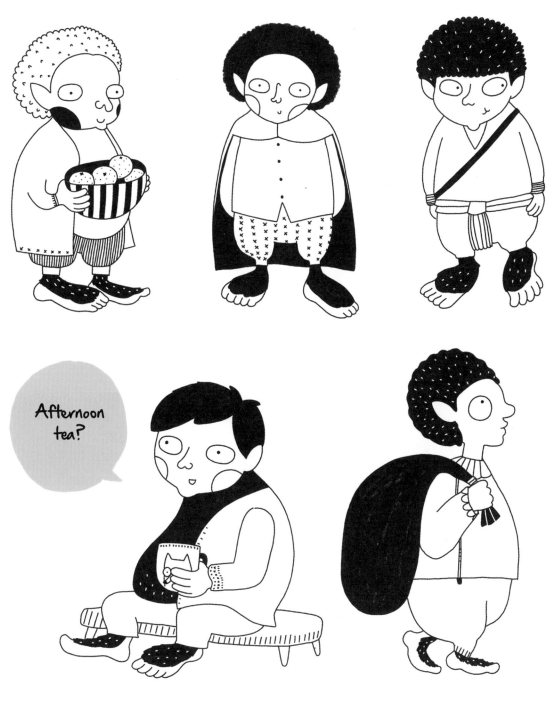

MAKE IT CUTE

DRAW AN IMP

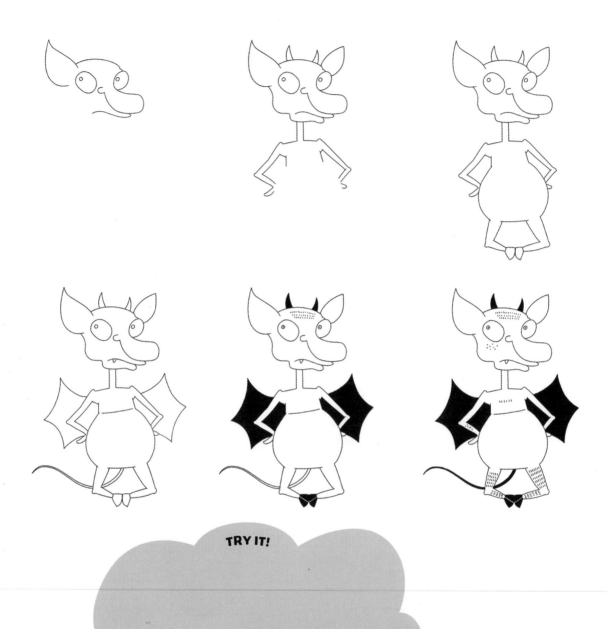

TRY IT!

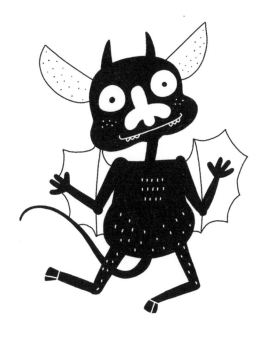

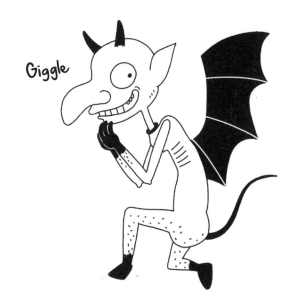

Giggle

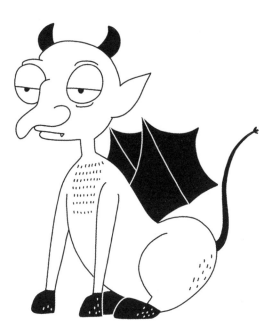

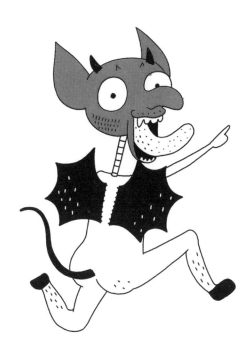

MAKE IT CUTE

DRAW A KRAKEN

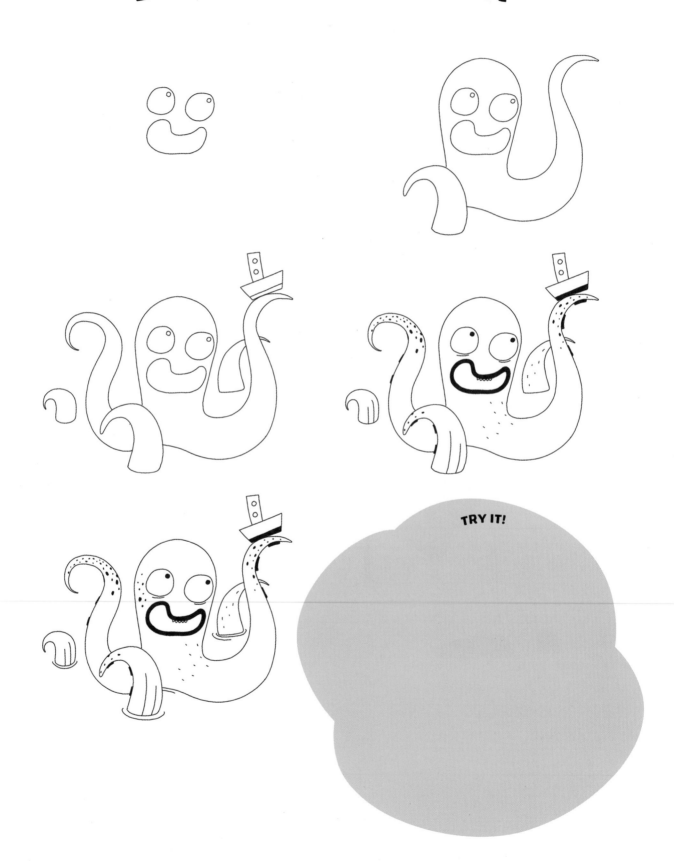

TRY IT!

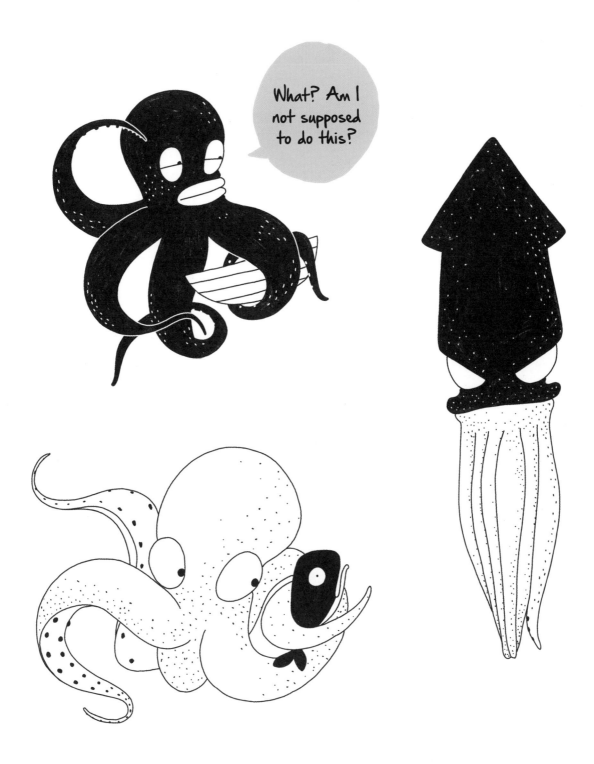

MAKE IT CUTE

DRAW A LEPRECHAUN

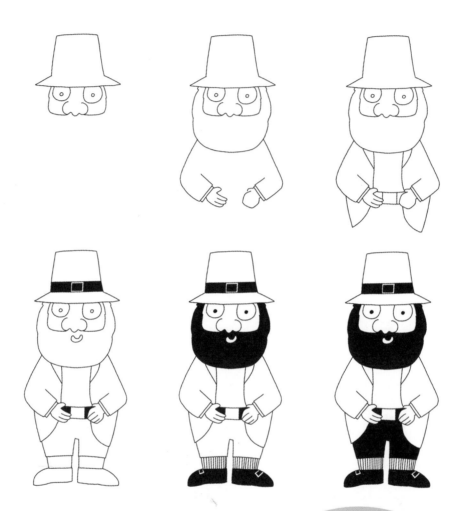

TRY IT!

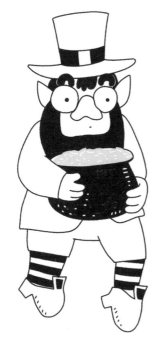

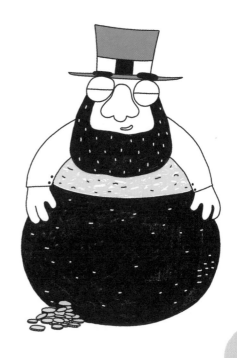

I'll be back!

MAKE IT CUTE

DRAW MEDUSA

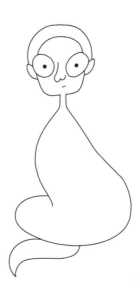
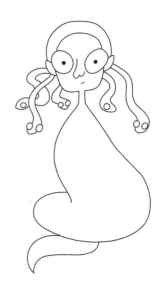

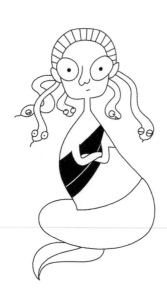
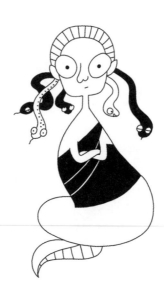
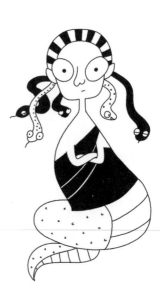

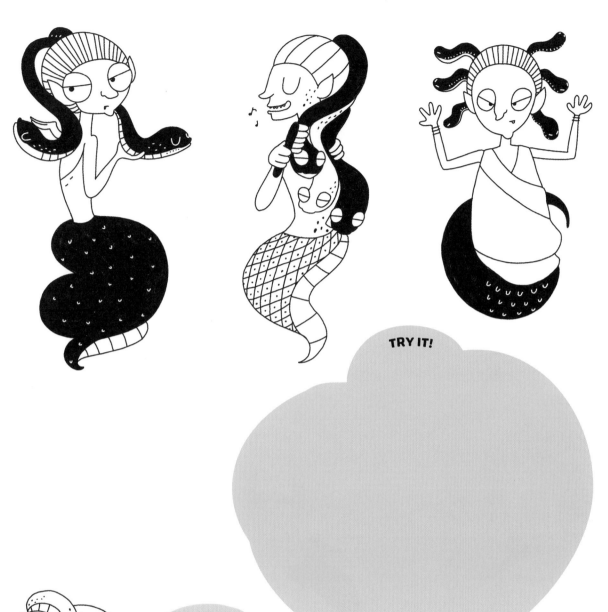

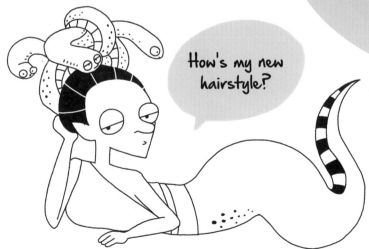

How's my new hairstyle?

MAKE HER CUTE

DRAW A MINOTAUR

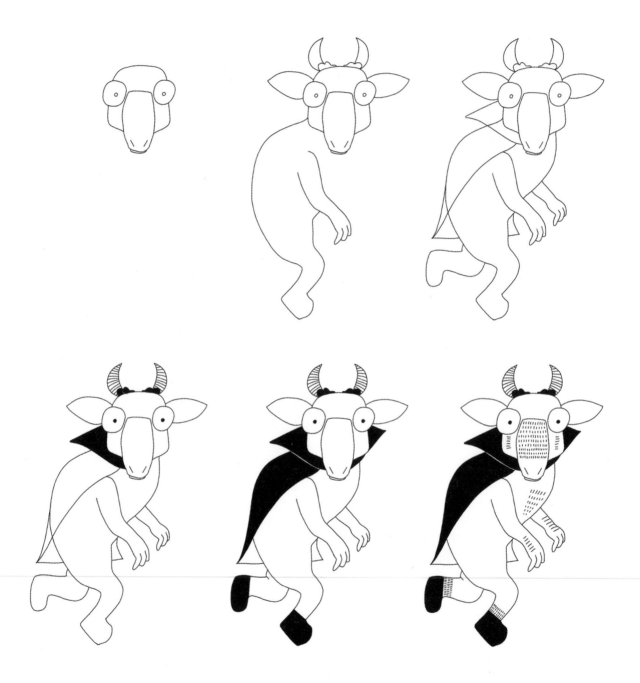

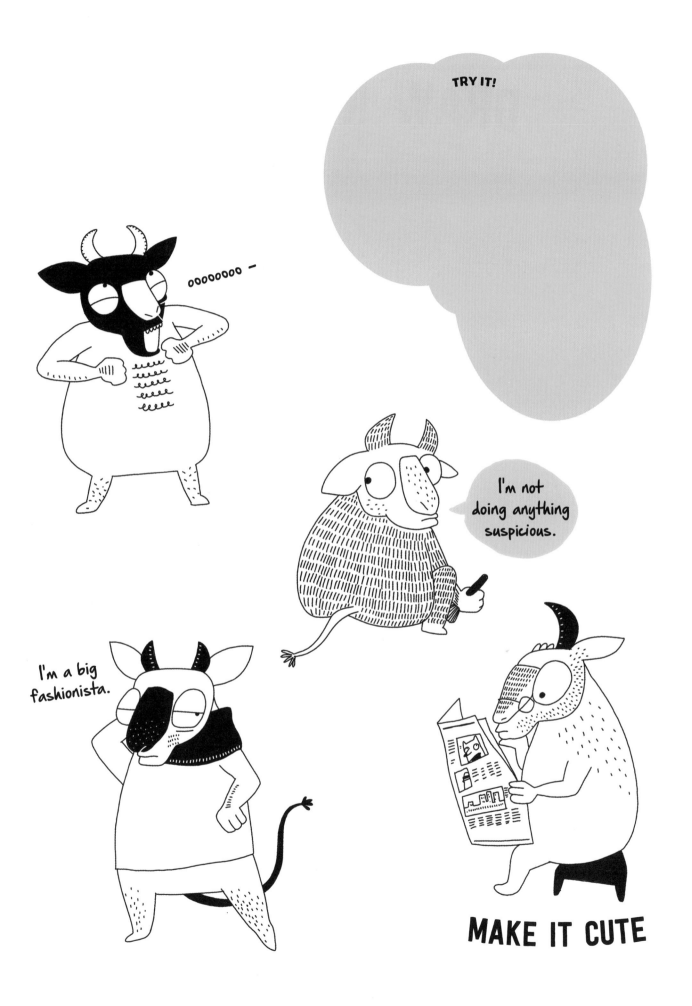

DRAW NESSIE

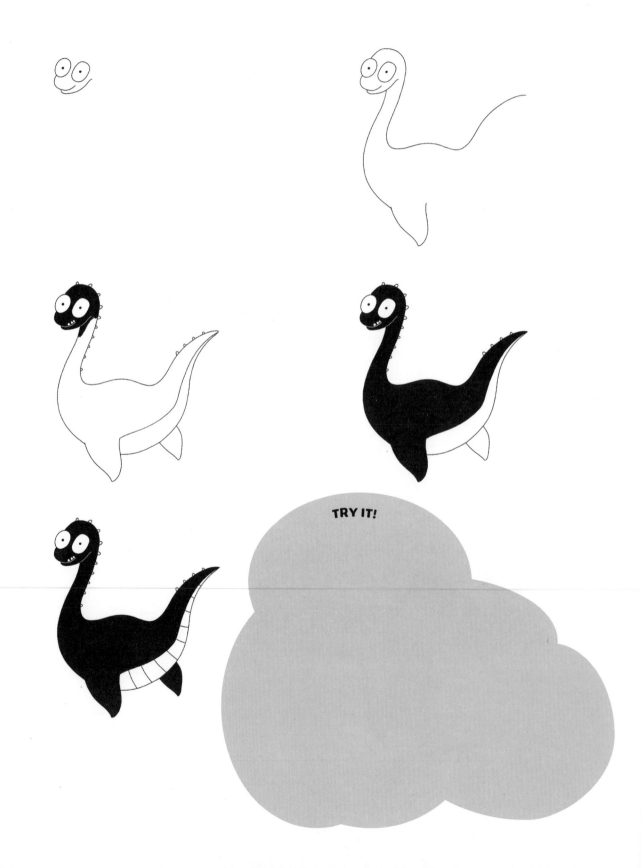

TRY IT!

66

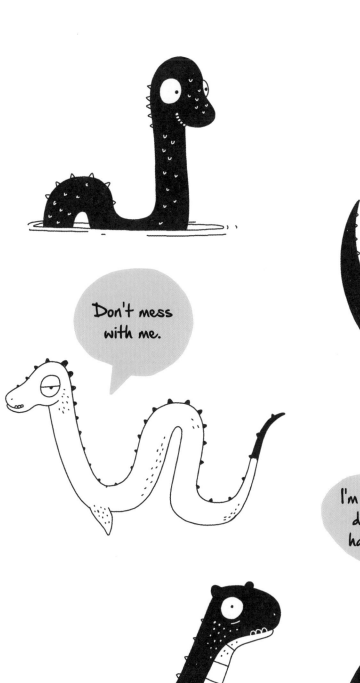

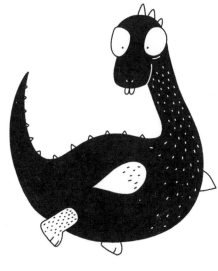

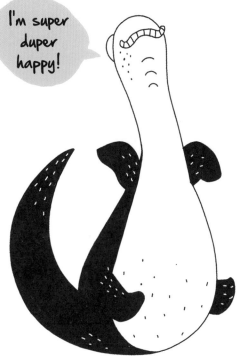

MAKE HER CUTE

DRAW AN OGRE

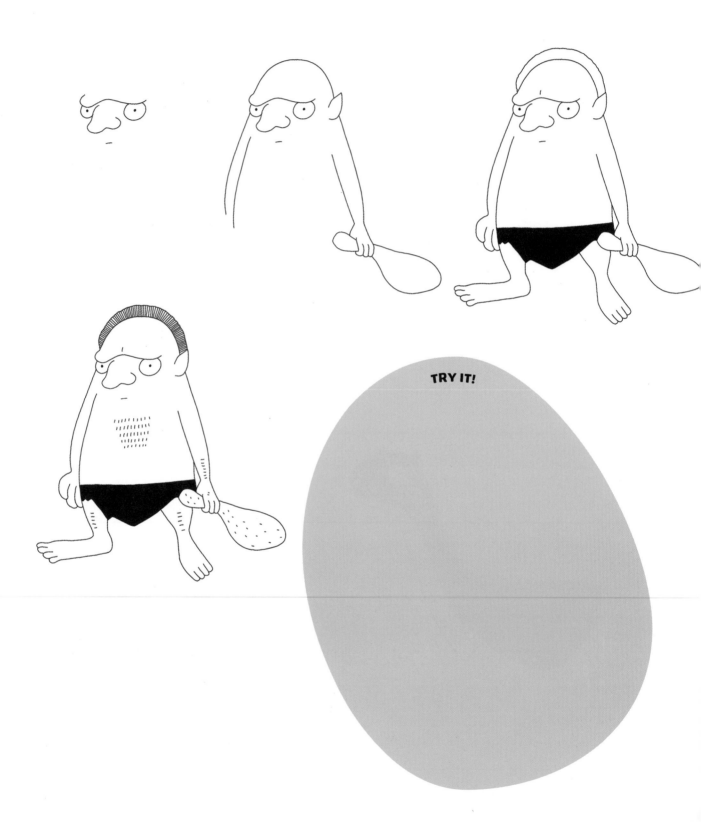

TRY IT!

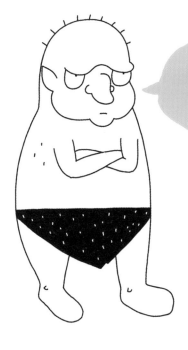

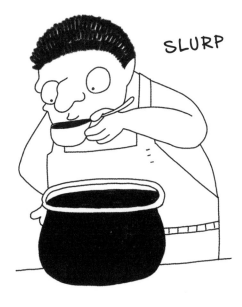

SLURP

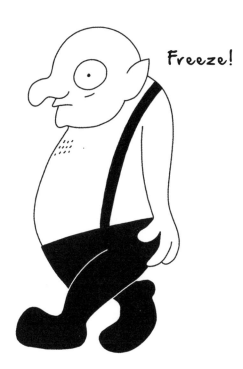

Freeze!

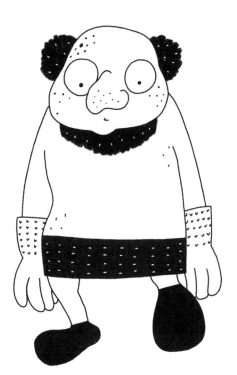

MAKE IT CUTE

DRAW AN ORC

 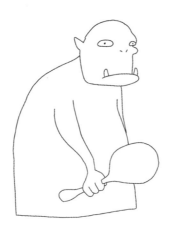 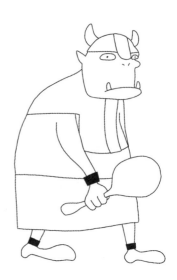

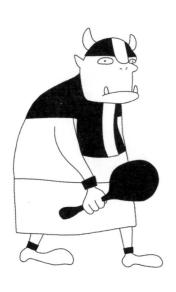 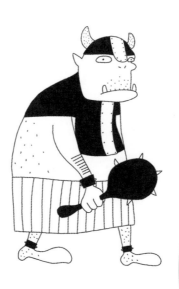

TRY IT!

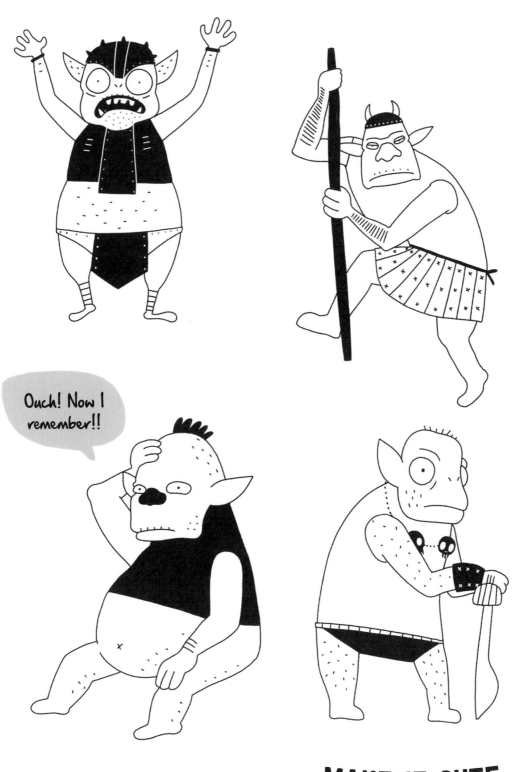

MAKE IT CUTE

DRAW A PEGASUS

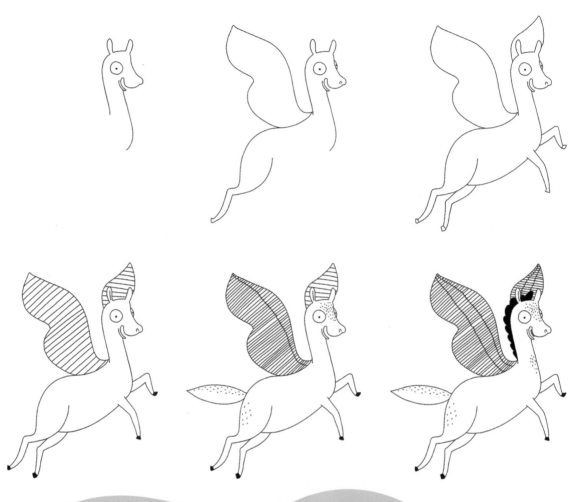

TRY IT!

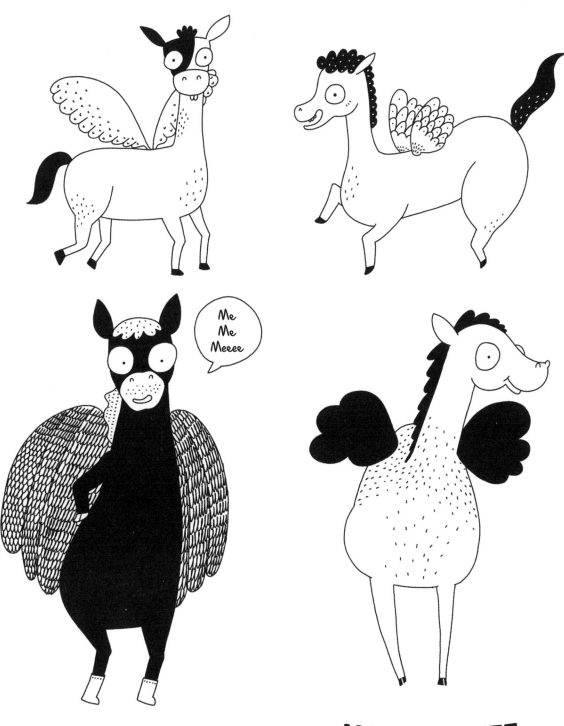

MAKE IT CUTE

DRAW A PHOENIX

TRY IT!

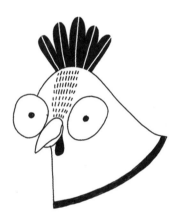

MAKE IT CUTE

→**TIP**← A phoenix is a regenerative bird, rising from the ashes. For your phoenix, experiment with different lines and methods to signify feathers. Use a variety of marks such as "V" or "U" shapes, dots, and zig zags. Repeat your marks in different ways to fill out the shapes.

DRAW RUMPELSTILTSKIN

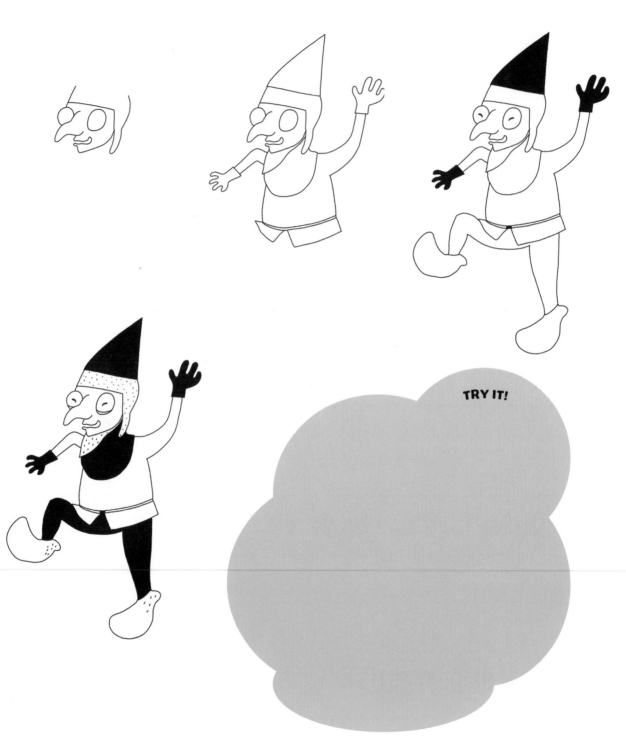

TRY IT!

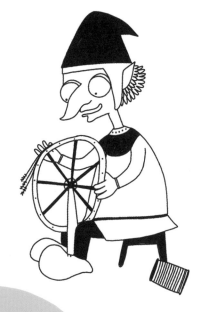

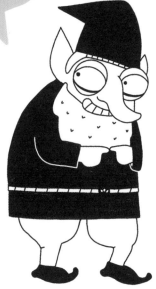

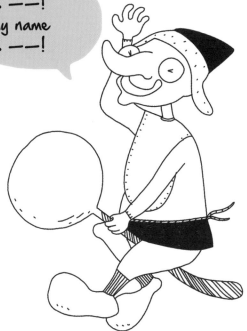

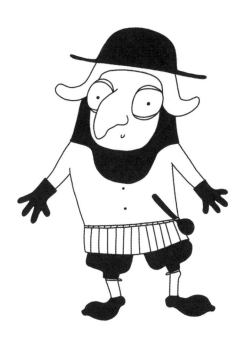

MAKE HIM CUTE

DRAW A SALAMANDER

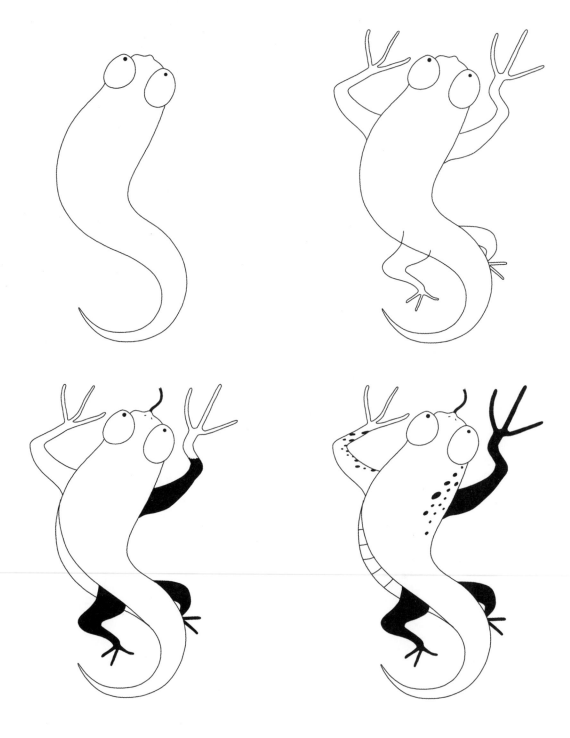

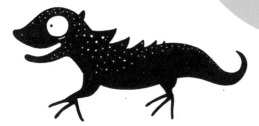

TRY IT!

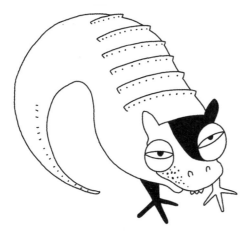

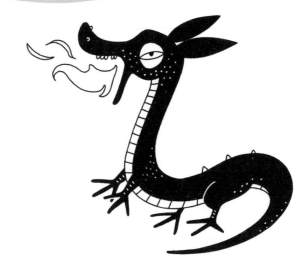

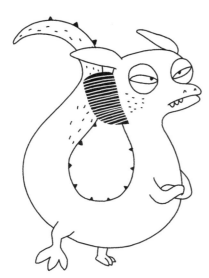

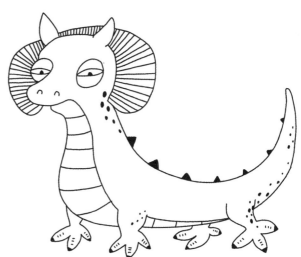

MAKE IT CUTE

DRAW A SEA HORSE

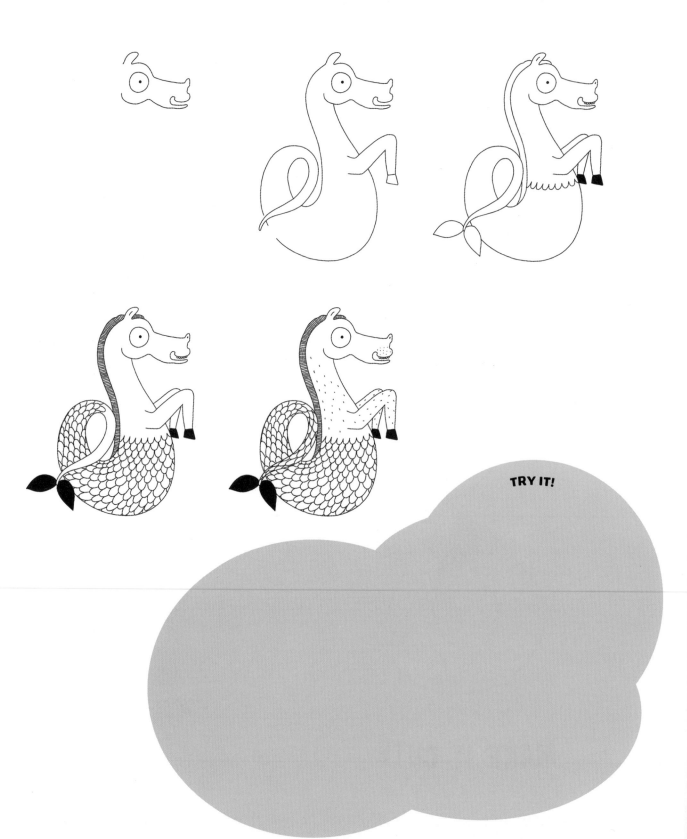

TRY IT!

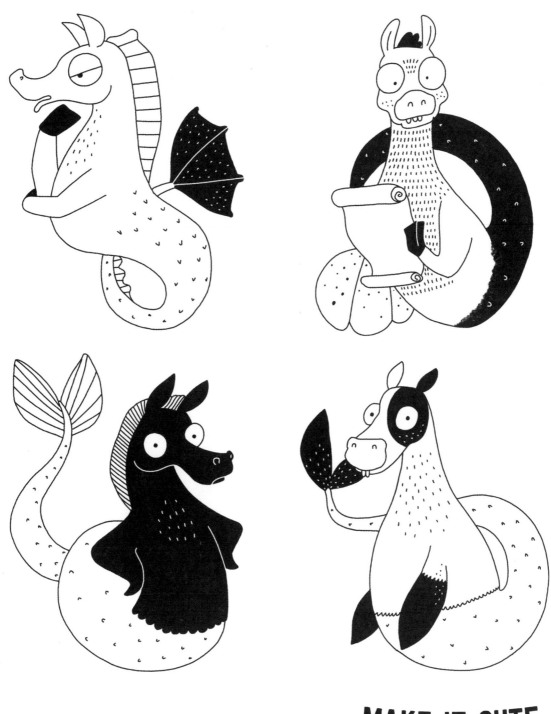

MAKE IT CUTE

DRAW A SIREN

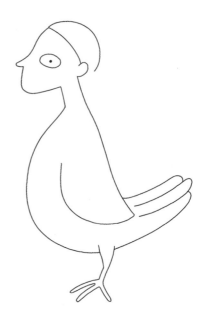

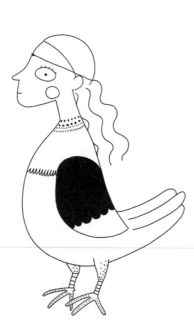

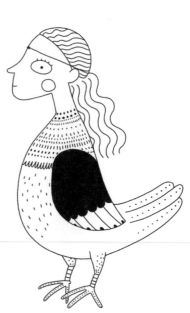

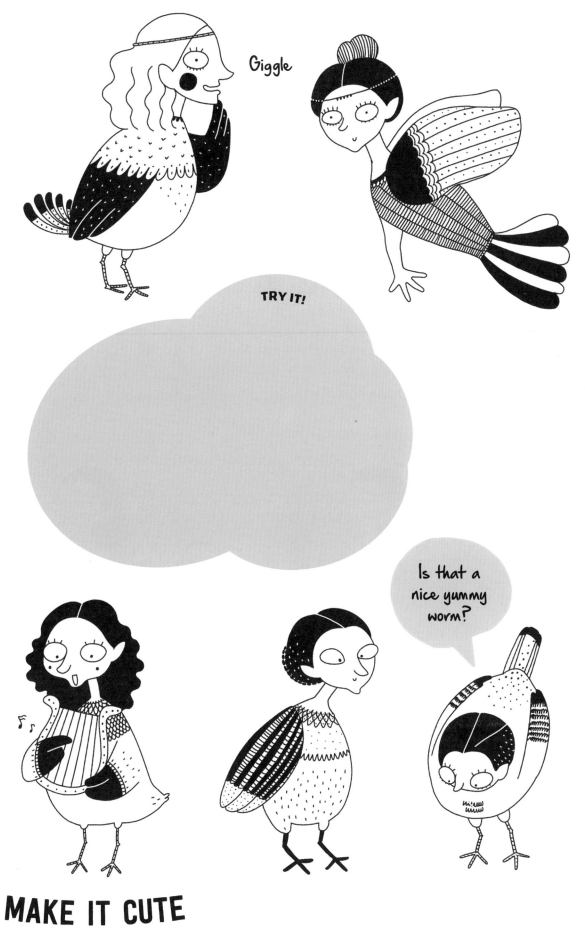

MAKE IT CUTE

DRAW A SPHINX

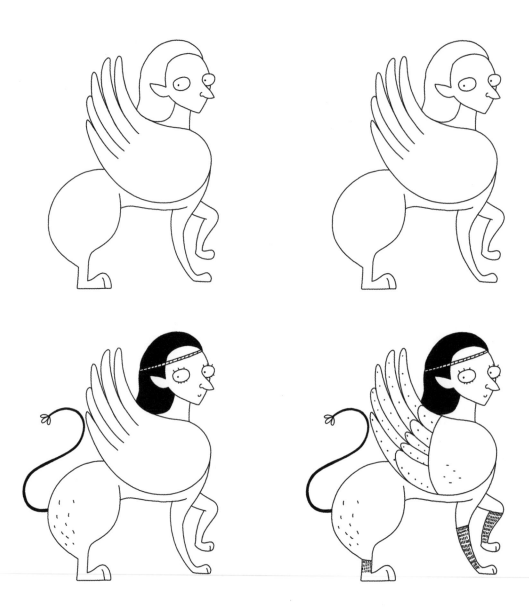

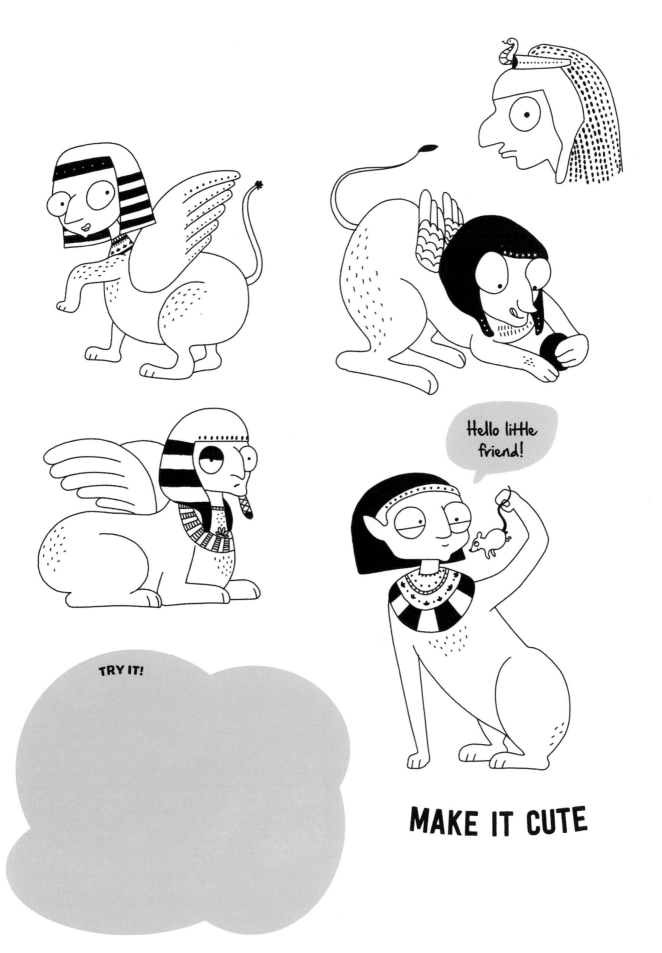

TRY IT!

MAKE IT CUTE

DRAW A TENGU

 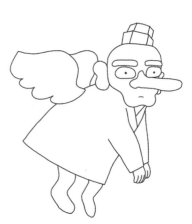

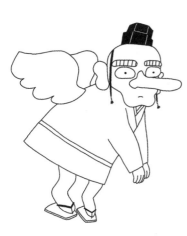 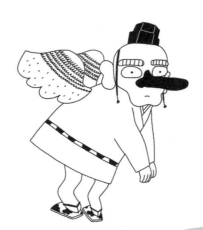

TRY IT!

→**TIP**← A Tengu is a legendary, supernatural creature found in Japanese folklore. Over the years, they have been portrayed in many ways, but often with human and avian characteristics. You can find many visual references for this character online in addition to the ones shown here. Make this version all your own!

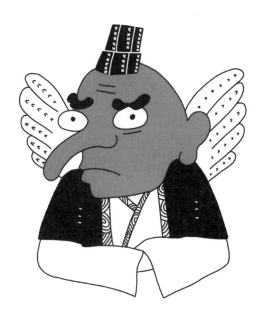

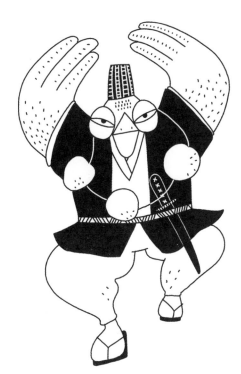

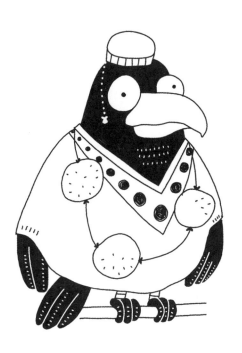

MAKE IT CUTE

DRAW A TROLL

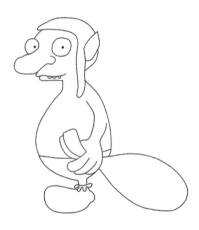

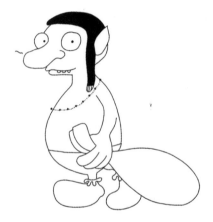

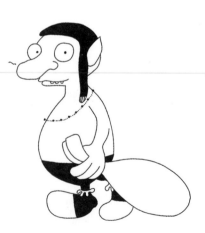

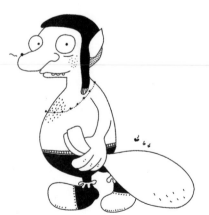

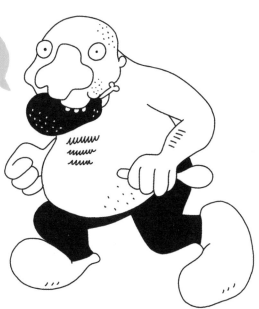

MAKE IT CUTE

TRY IT!

DRAW A VAMPIRE

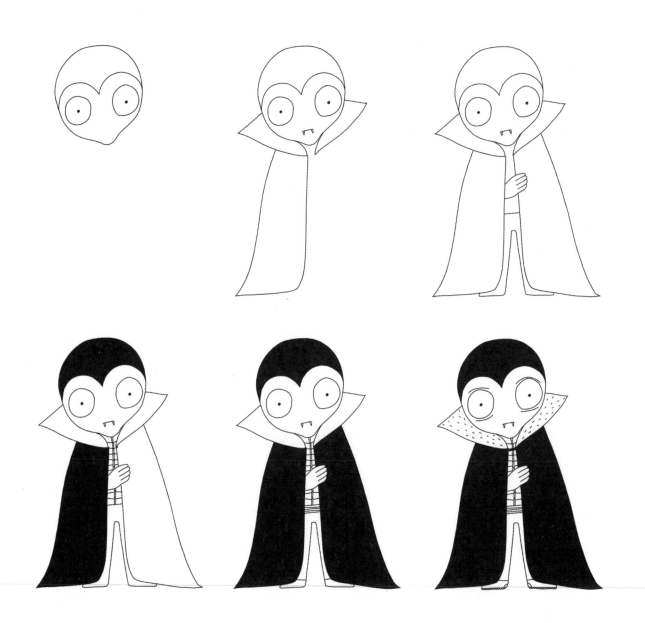

→ **TIP** ← Vampires comes in all shapes and sizes. I kept mine simple, with a widow's peak and traditional cape. Focus on your vampire's eyes: How can you make them look vacant and frightening? Or timid and innocent? Experiment with the lines around the eyes to change the expression.

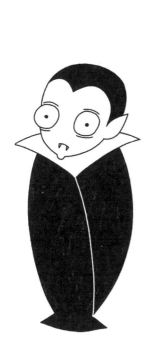

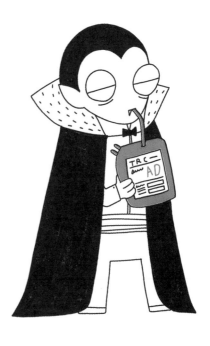

TRY IT!

I need a tan.

MAKE IT CUTE

DRAW A WEREWOLF

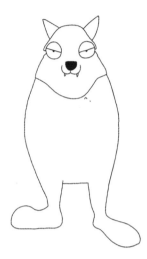

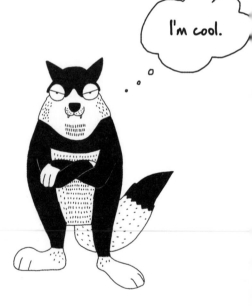

I'm cool.

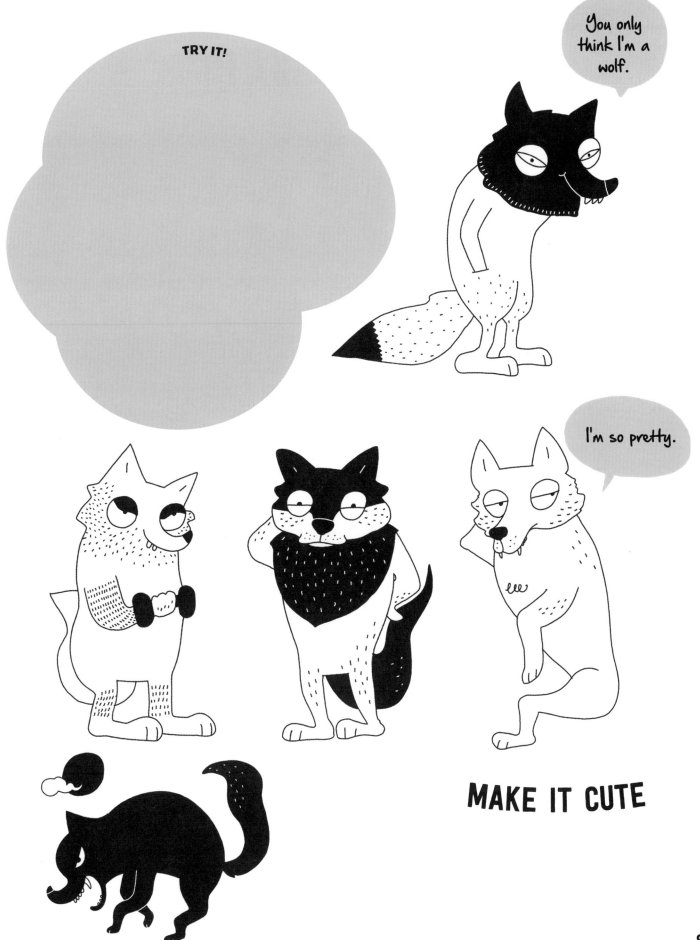

TRY IT!

You only think I'm a wolf.

I'm so pretty.

MAKE IT CUTE

DRAW A YALE

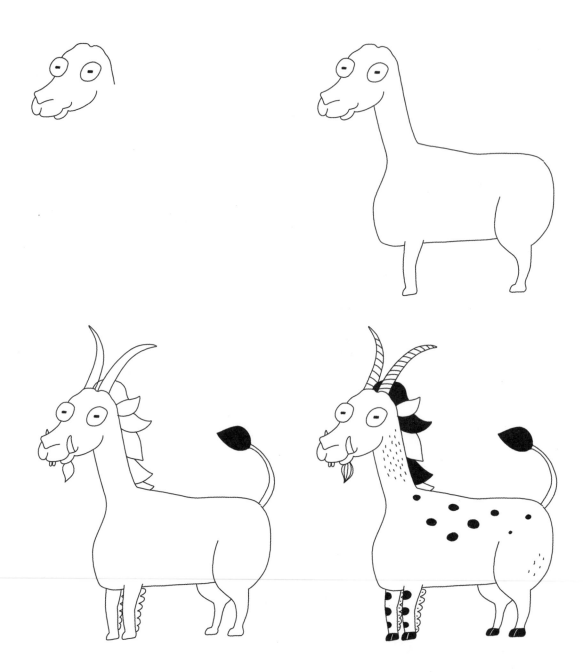

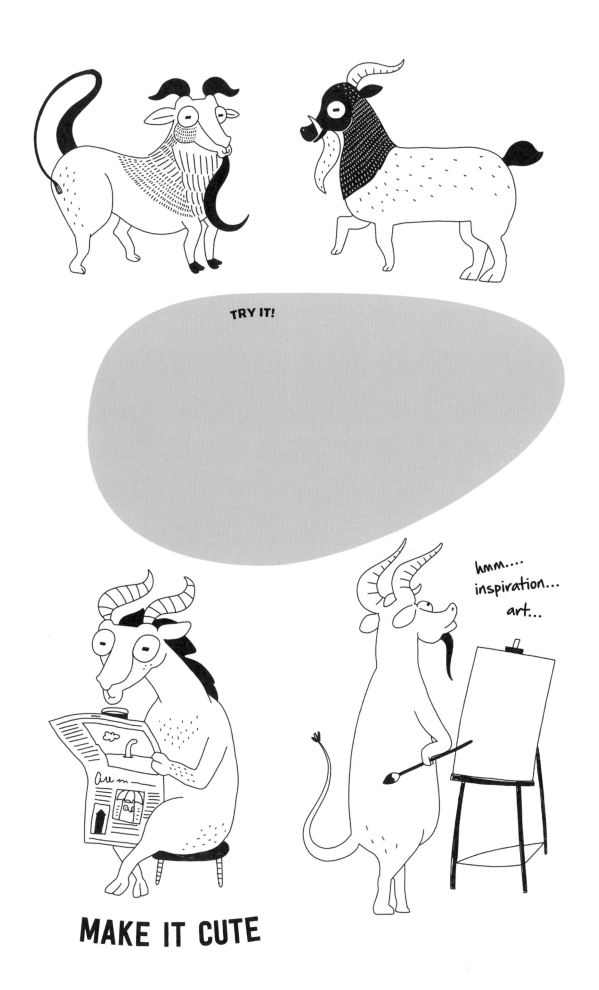

TRY IT!

MAKE IT CUTE

DRAW A YETI

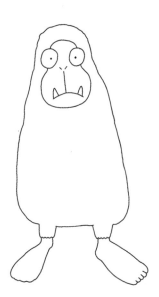
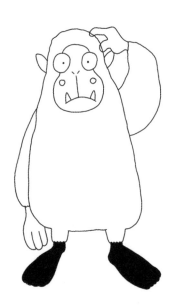

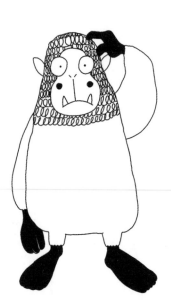
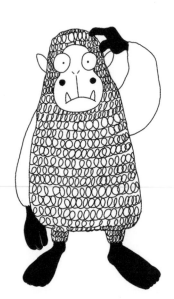
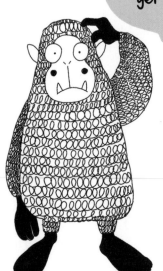

I don't get it.

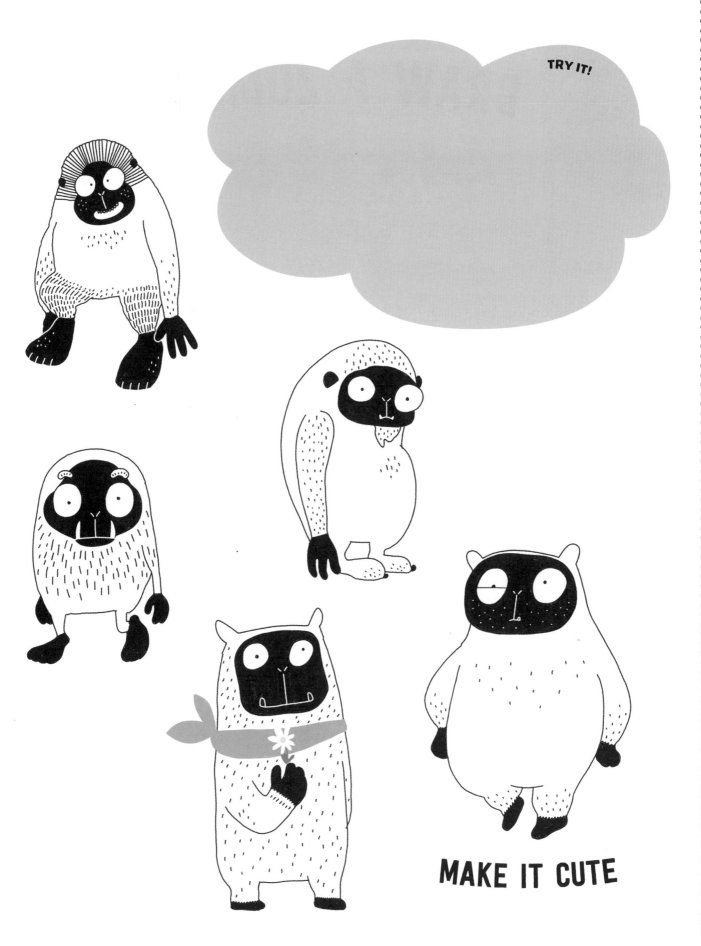

MAKE IT CUTE

DRAW A ZOMBIE

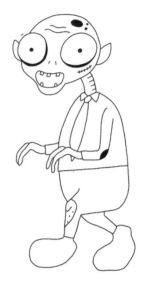

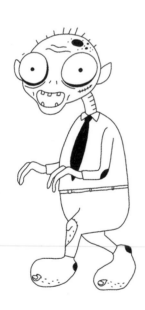

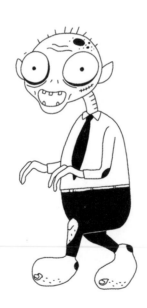

TRY IT!

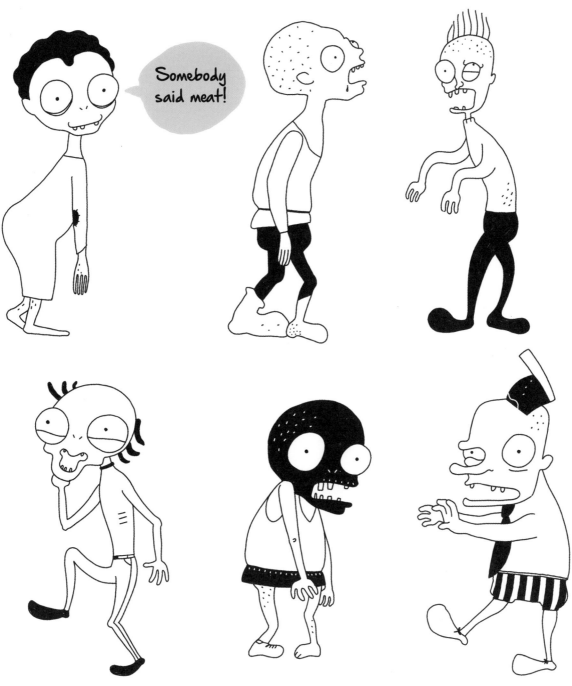

MAKE IT CUTE

DRAW A FLOWER FAIRY

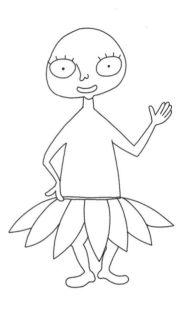
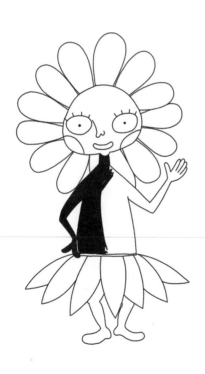
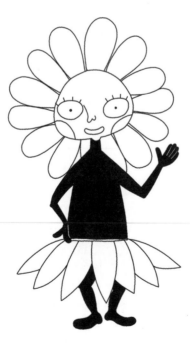
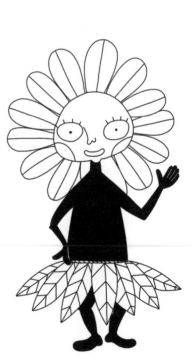

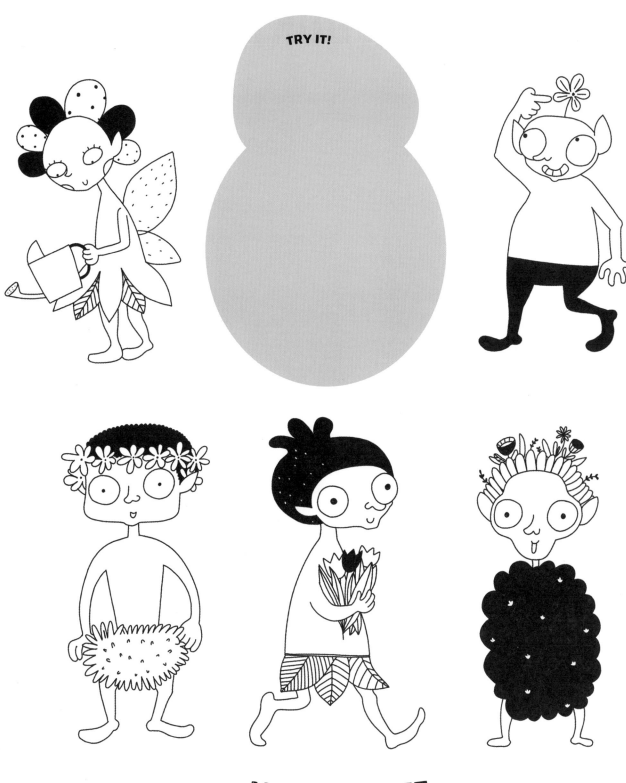

TRY IT!

MAKE IT CUTE

DRAW A DOKKAEBI

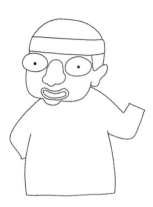
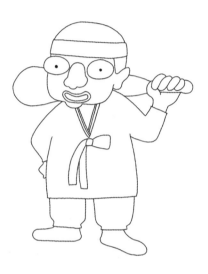
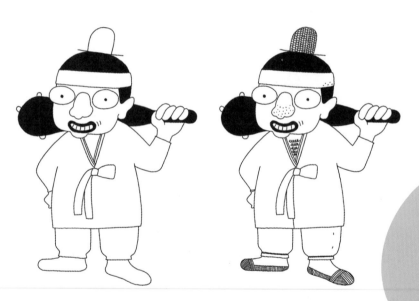

TRY IT!

⇒**TIP**⇐ A Dokkaebi is a Korean mythological **character.** My wildly different versions share a common nose. Try drawing features "on top" of the face to create the look of a mask. Use a variety of historical references to transform each iteration of your character.

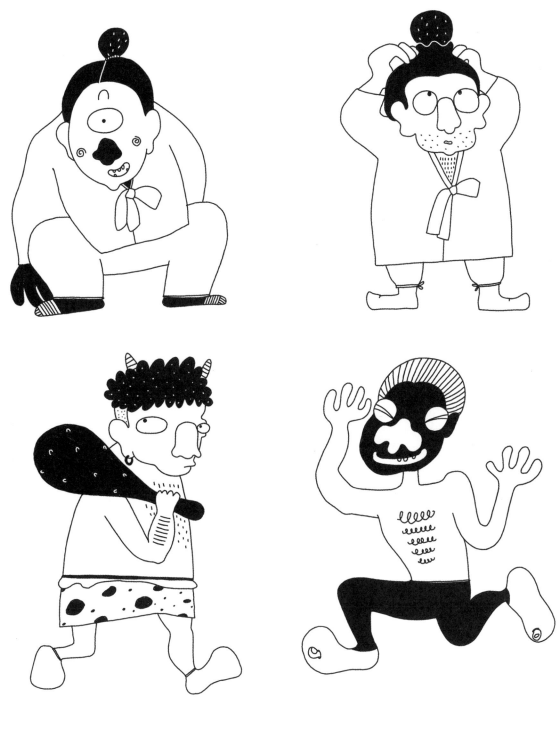

MAKE IT CUTE

DRAW AN ENCHANTED ELEPHANT

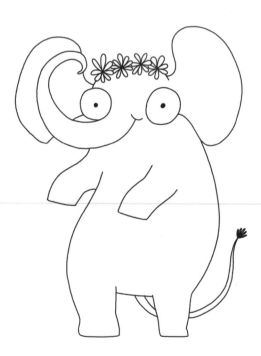

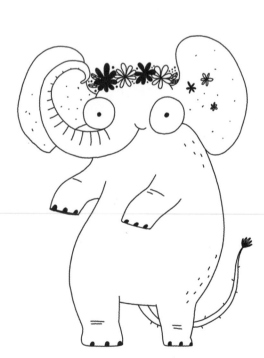

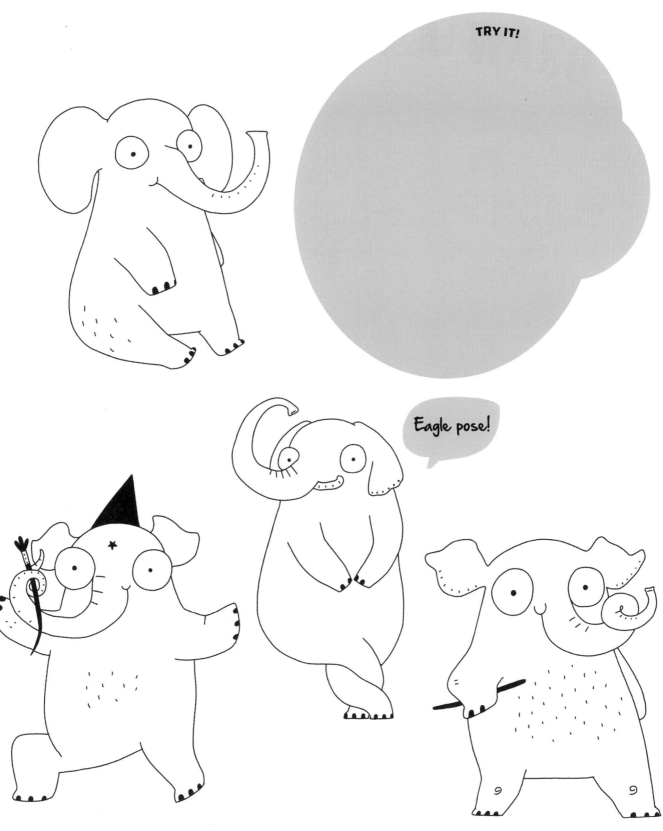

TRY IT!

Eagle pose!

MAKE IT CUTE

DRAW A FOREST FAIRY

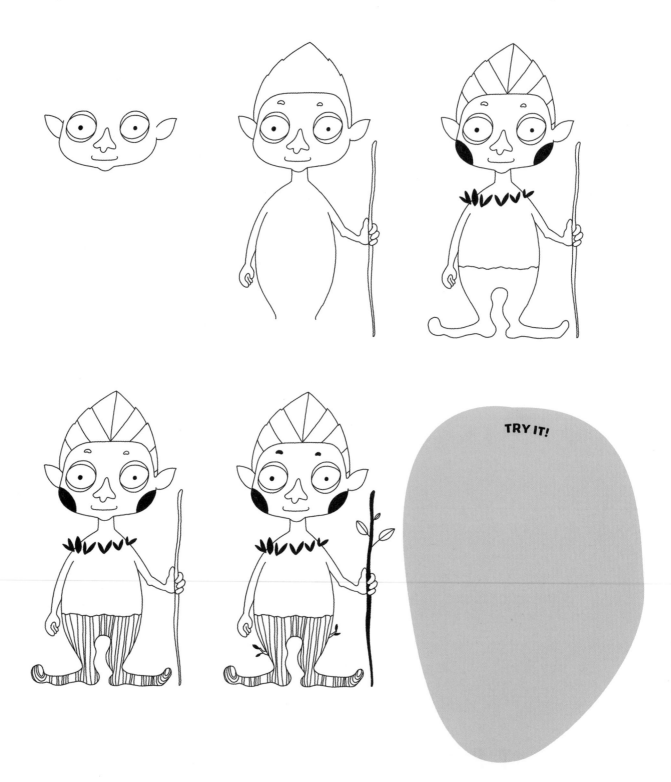

TRY IT!

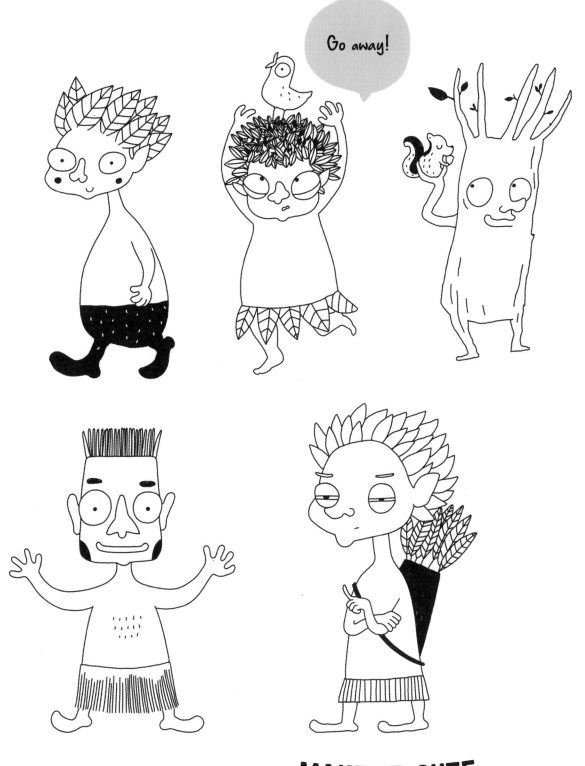

MAKE IT CUTE

DRAW A GENIE

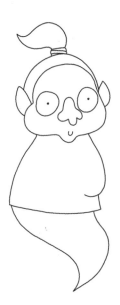

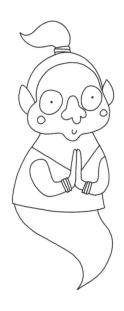

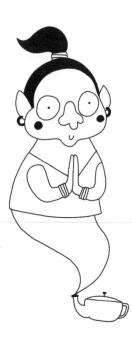

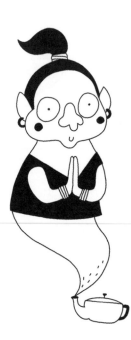

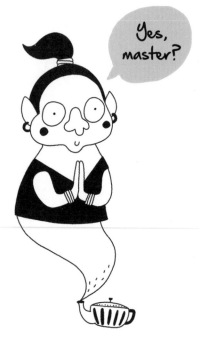

Yes, master?

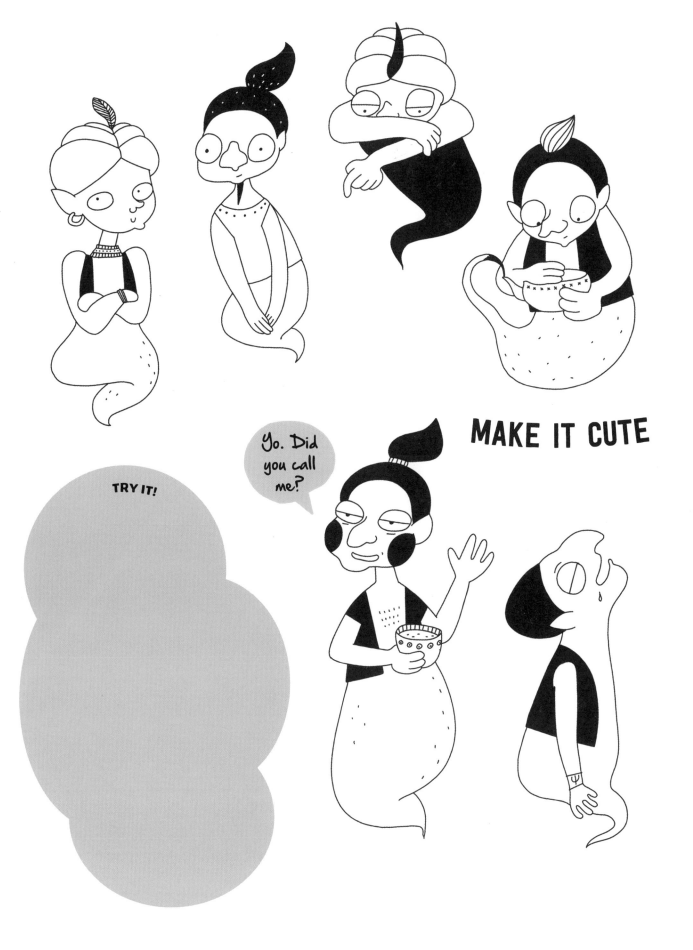

MAKE IT CUTE

TRY IT!

Yo. Did you call me?

DRAW A KUMIHO

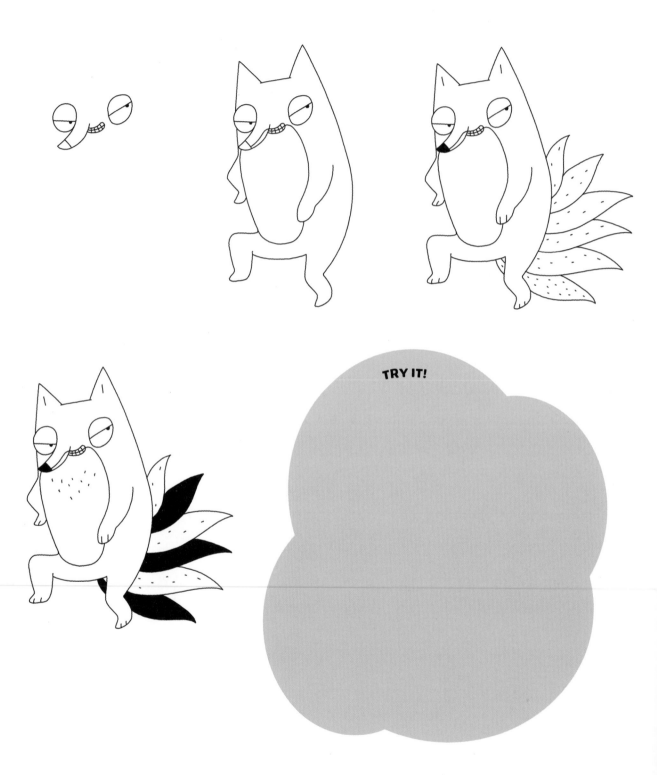

TRY IT!

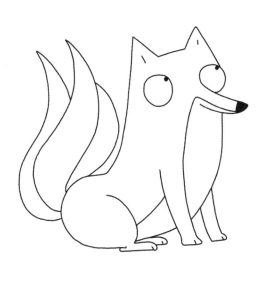

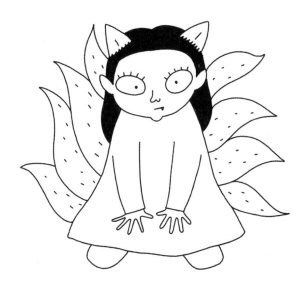

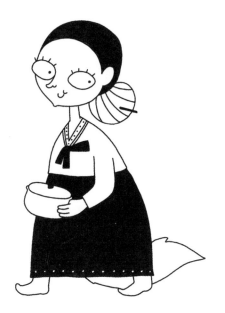

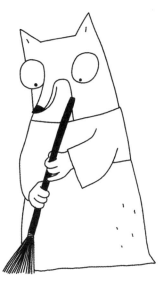

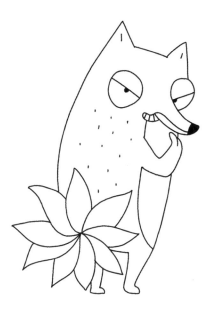

MAKE IT CUTE

DRAW A GRUMPY WIZARD

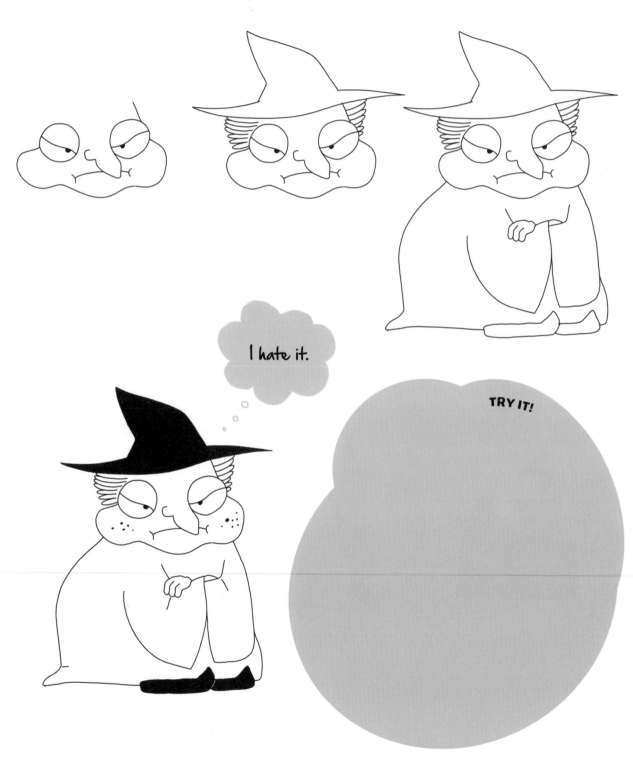

I hate it.

TRY IT!

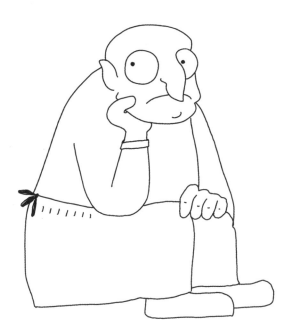

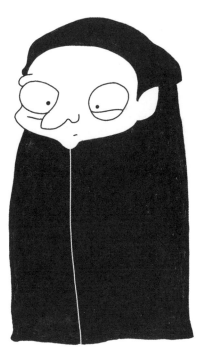

MAKE IT CUTE

DRAW A FLYING MONKEY

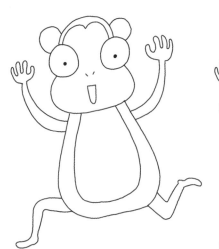

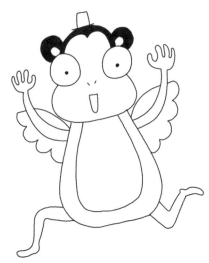

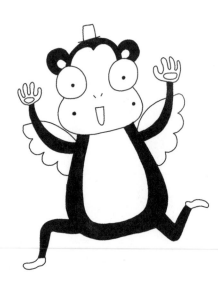

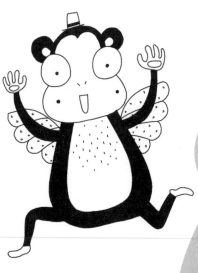

TRY IT!

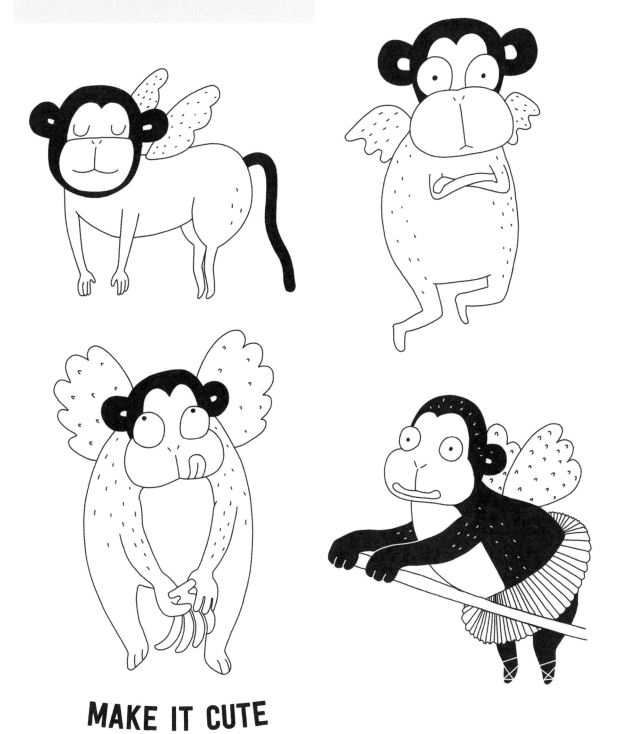

MAKE IT CUTE

DRAW A MUMMY

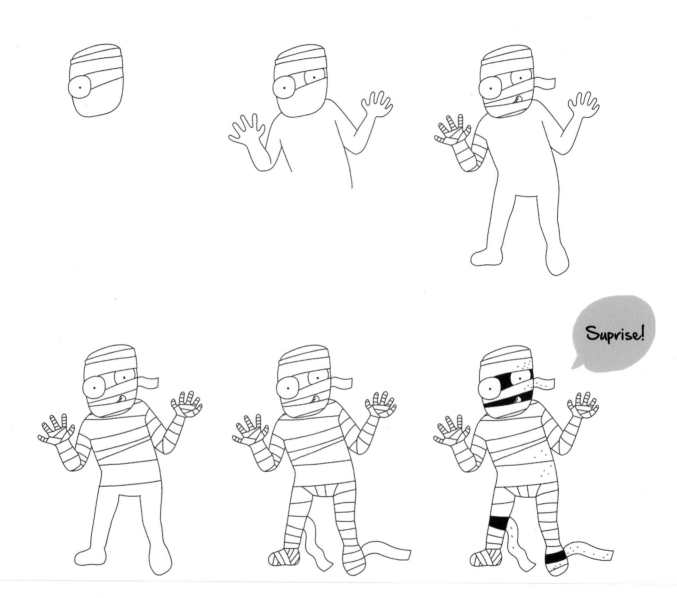

Suprise!

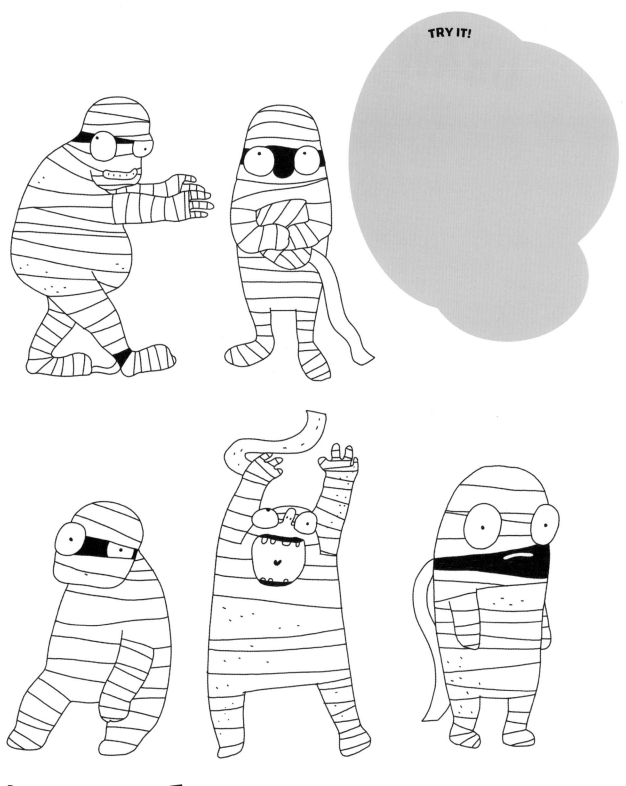

TRY IT!

MAKE IT CUTE

DRAW A HOUSE ELF

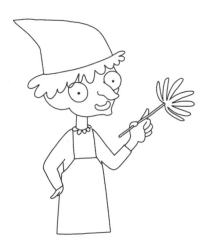

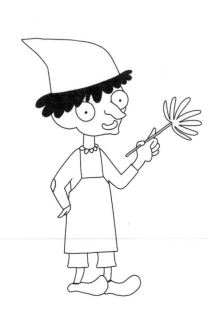
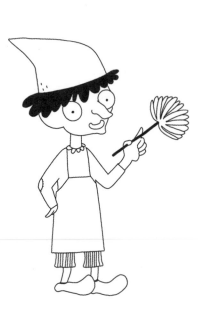
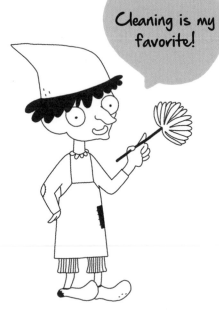

Cleaning is my favorite!

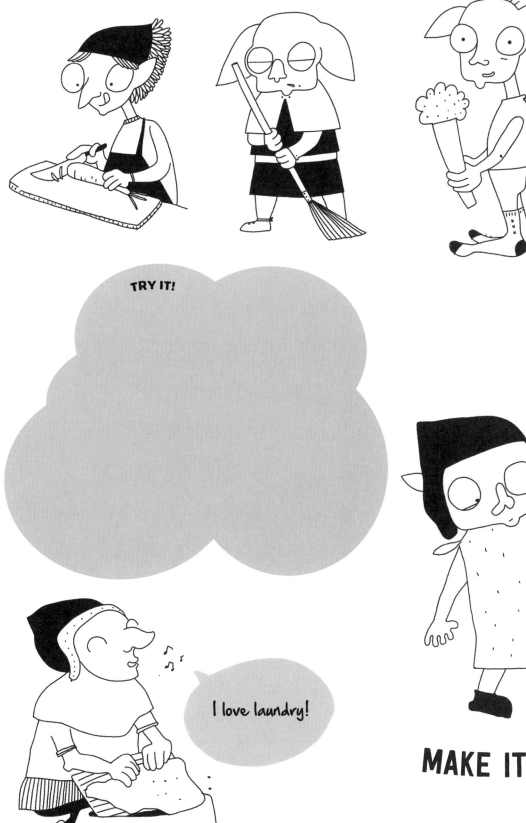

TRY IT!

I love laundry!

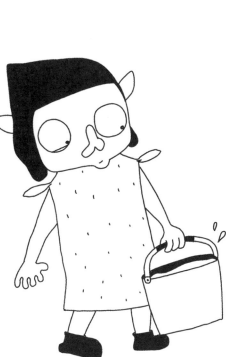

MAKE IT CUTE

DRAW THE MAJESTIC CORGI

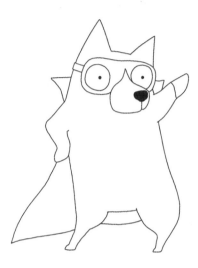

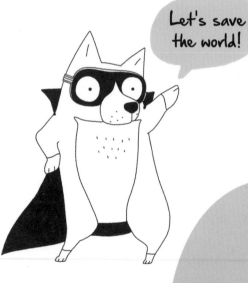

Let's save the world!

TRY IT!

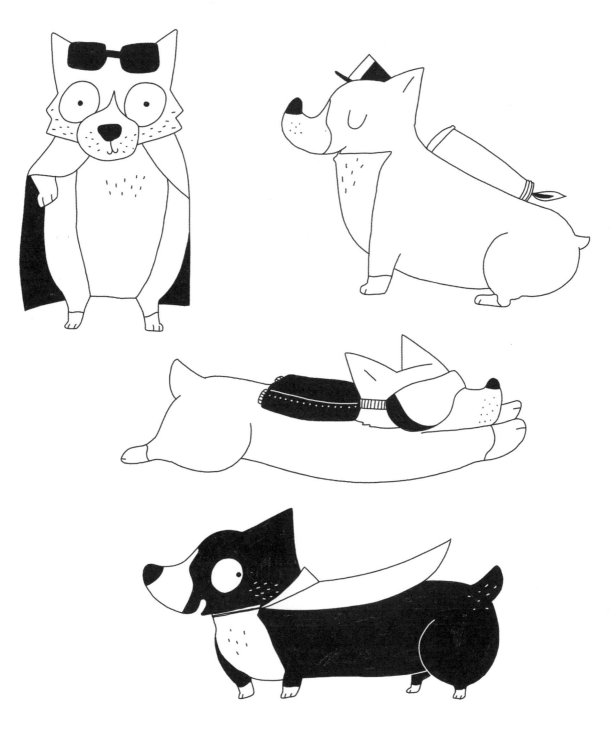

MAKE IT CUTE

DRAW A MERMAN

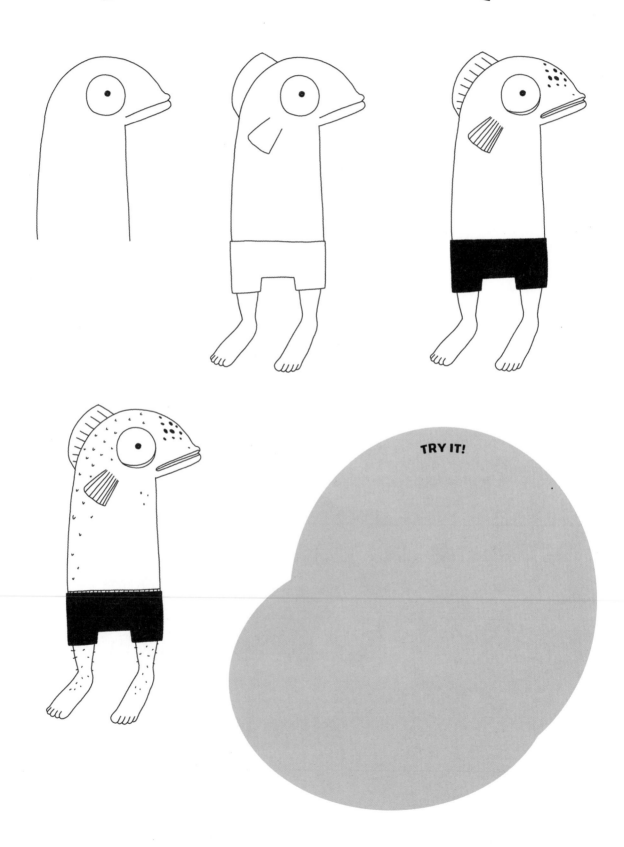

TRY IT!

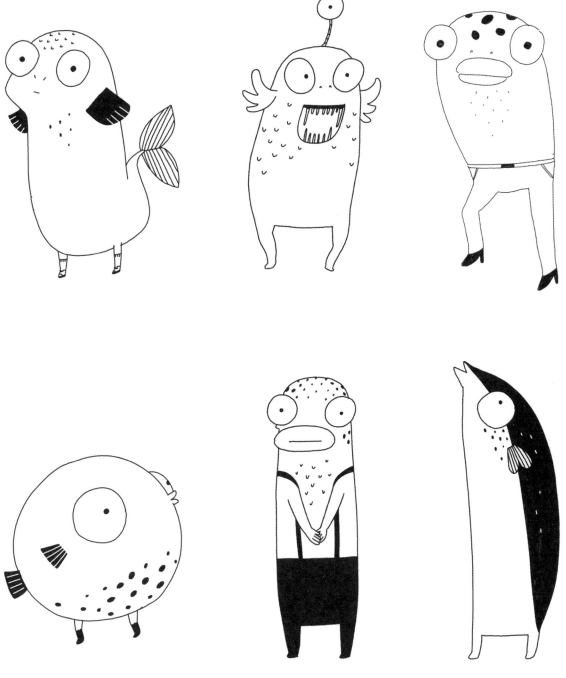

MAKE HIM CUTE

DRAW A MAINE COON

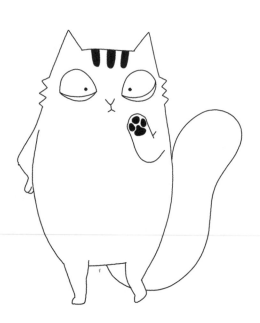

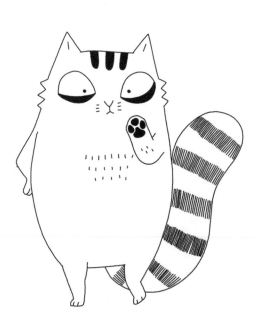

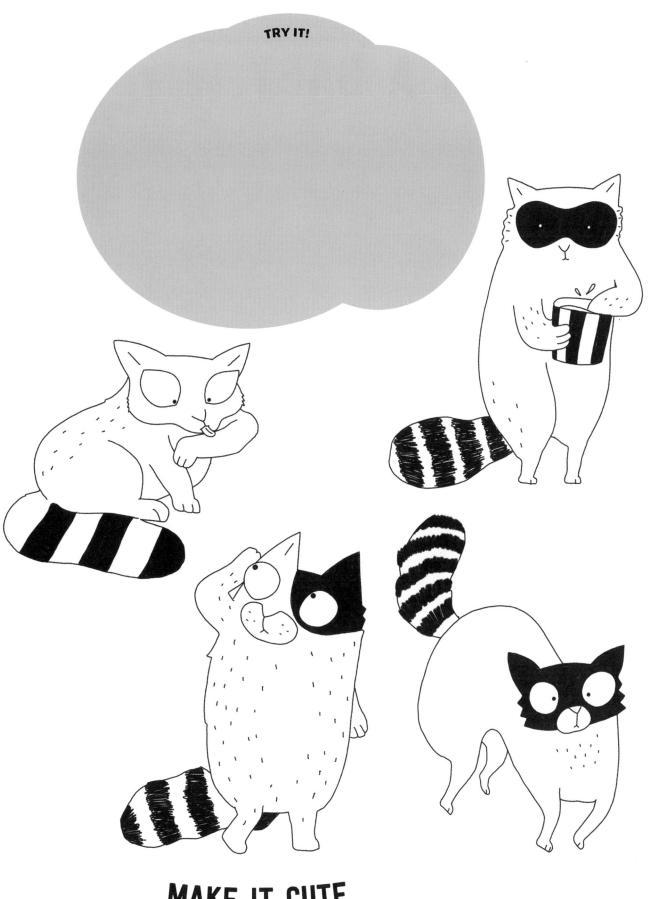

TRY IT!

MAKE IT CUTE

DRAW A BABY WITCH

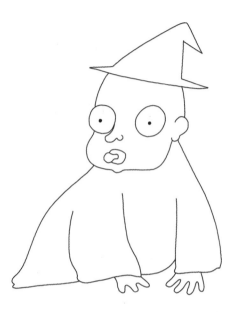

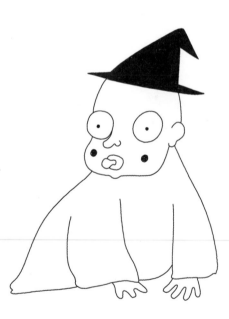

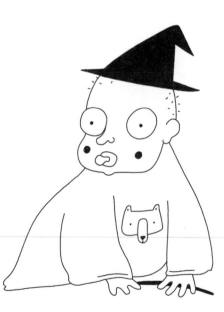

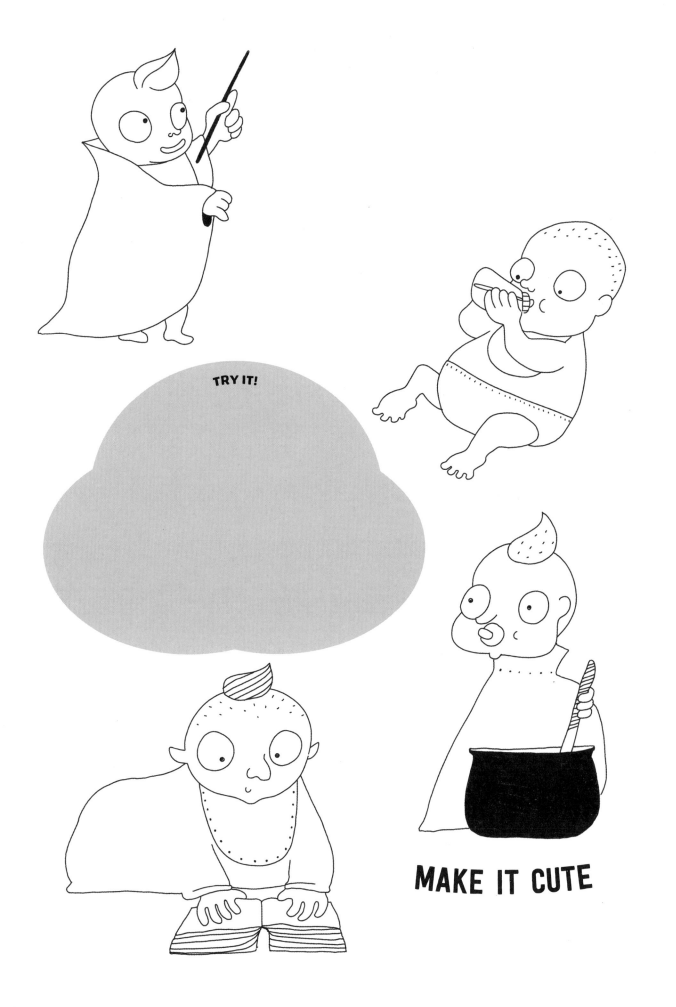

TRY IT!

MAKE IT CUTE

ABOUT THE AUTHOR

Heegyum Kim is graphic designer and illustrator. She holds a master of science in communication design from Pratt Institute. She is the author and illustrator of *Draw 62 Animals and Make Them Cute*, the first book in this series. She is the also author of two illustrated books featuring Mr. Fox, the charming and humorous character whose activities and musings drive her popular Instagram account and make her followers giggle, as do a menagerie of other delightful animal friends. She lives in Jersey City, New Jersey. Follow her drawing adventures on Instagram: www.instagram.com/hee_cookingdiary

Brimming with creative inspiration, how-to projects, and useful information to enrich your everyday life, Quarto Knows is a favorite destination for those pursuing their interests and passions. Visit our site and dig deeper with our books into your area of interest: Quarto Creates, Quarto Cooks, Quarto Homes, Quarto Lives, Quarto Drives, Quarto Explores, Quarto Gifts, or Quarto Kids.

Inspiring | Educating | Creating | Entertaining

First Published in 2019 by Quarry Books, an imprint of The Quarto Group, 100 Cummings Center, Suite 265-D, Beverly, MA 01915, USA. T (978) 282-9590 F (978) 283-2742 QuartoKnows.com

Quarry Books titles are also available at discount for retail, wholesale, promotional, and bulk purchase. For details, contact the Special Sales Manager by email at specialsales@quarto.com or by mail at The Quarto Group, Attn: Special Sales Manager, 100 Cummings Center, Suite 265-D, Beverly, MA 01915, USA.

10 9 8 7 6 5 4 3 2 1

ISBN: 978-1-63159-682-7

Digital edition published in 2019
eISBN: 978-1-61359-683-4

Library of Congress Cataloging-in-Publication Data available

Design: Debbie Berne

Printed in China

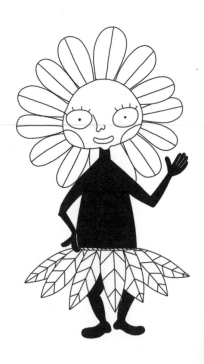